Wyndham Lewis titles published by Black Sparrow Press:

The Apes of God (novel) (1981)
BLAST 1 (journal) (1981)
BLAST 2 (journal) (1981)
The Complete Wild Body (stories) (1982)
Journey into Barbary (travel) (1983)
Self Condemned (novel) (1983)
Snooty Baronet (novel) (1984)
BLAST 3 (journal) (1984)
Rude Assignment (autobiography) (1984)
The Vulgar Streak (novel) (1985)
Rotting Hill (stories) (1986)
The Caliph's Design (essays) (1986)

Forthcoming:

Men Without Art (essays)
Time and Western Man (philosophy)

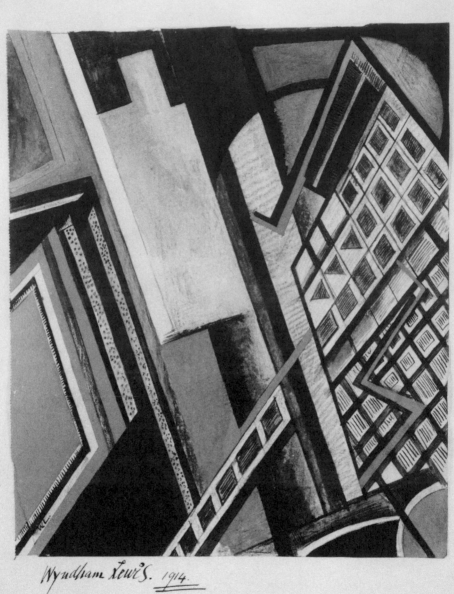

Wyndham Lewis. 1914.

WYNDHAM LEWIS

THE CALIPH'S DESIGN

Architects! Where is your Vortex?

Edited with
Afterword & Notes
by
PAUL EDWARDS

Black Sparrow Press
Santa Barbara · 1986

Grateful acknowledgement must be made to Andrew Wilson
for providing me with valuable information about Wyndham
Lewis's contacts with Theo Van Doesburg. My thanks to Colin
Christmas, Seamus Cooney, Richard Humphreys, and Catherine
Herbert of the Department of Rare Books, Cornell University
Library. Thanks and acknowledgement are also due to the Tate
Gallery, London for permission to reproduce the cover illustra-
tion. The interior illustrations are reproduced by the courtesy
of the Anthony d'Offay Gallery, London.

P. E.

The editor and publisher dedicate this new edition
to the memory of Bernard Lafourcade (1934–1986).

LIBRARY OF CONGRESS CATALOGING-IN-PUBLICATION DATA

Lewis, Wyndham, 1882-1957.
 The caliph's design.

 1. Avant-garde (Aesthetics)—History—19th century.
2. Avant-garde (Aesthetics)—History—20th century.
I. Edwards, Paul, 1950— . II. Title.
N6447.L49 1986 701'.1'7 86-3560

ISBN 0-87685-665-2
ISBN 0-87685-666-0 (deluxe)
ISBN 0-87685-664-4 (pbk.)

CONTENTS

Editor's Note 7

AUTHOR'S PREFACE 9

PART I

THE CALIPH'S DESIGN

The Parable of the Caliph's Design 19

The Bull Sounds 21

The Politician's Apathy 27

How the Fact of Style Obstructs 33

Where the Painter Would Benefit 37

The Public Chosen 41

Architecture 43

Child Art and the Naif 51

Machinery and Lions 57

The Artist's Luck 61

PART II

THE ARTIST OLDER THAN THE FISH

The Artist Older than the Fish 65

The Physiognomy of Our Time 73

Fashion 79

PART III

PARIS

French Realism 85
The Uses of Fashion 89
Cézanne 99
The General Tendency in Paris 101
Matisse and Derain 105
Picasso 109

PART IV

THE STUDIO GAME

Foreword to Part IV 119
Our Aesthetes and Plank-Art 123
The Bawdy Critic 127
"We Fell in Love with the Beautiful Tiles in
 the South Kensington Museum
 Refreshment Room" 131
The Vengeance of Raphael 137
General Nature and the Specialised Sense 141

APPENDICES

Afterword 145
Note on the Illustrations 165
Explanatory Notes 169
Table of Variants 183

EDITOR'S NOTE

THE TEXT OF THIS EDITION of *The Caliph's Design* follows that of the first edition, published by The Egoist in London in 1919. Lewis's original manuscript has disappeared. The present text exactly follows the 1919 text apart from the minor exceptions listed in the Table of Variants on page 183.

Wyndham Lewis revised the text of *The Caliph's Design* for inclusion in his 1939 collection of his writings on art, *Wyndham Lewis the Artist: From Blast to Burlington House* (London: Laidlaw and Laidlaw, 1939), and this text is reprinted in *Wyndham Lewis on Art*, ed. C. J. Fox and Walter Michel (London: Thames and Hudson, 1969). The revisions are mainly stylistic, but some are substantive. For the reader's convenience the more significant revisions are indicated in the Explanatory Notes. In annotating, the editor has assumed that the reader has a general knowledge of modern art and artists, and has adopted a restrained policy rather than clutter the apparatus with superfluous information.

AUTHOR'S PREFACE

I HAVE ASSEMBLED round my parable a series of short articles and notes. They are all related to the idea that this parable embodies. The second half of this pamphlet deals with that section of modern painting that is incompatible with any constructive tendency.° I give my reasons for believing that it gains nothing from this incompatibility; and, furthermore, that this incompatibility is a diagnostic of fatigue in the painting in question.

The spirit that pervades a large block—cube, if you like—of the art of painting to-day is an almost purely Art-for-Art's sake dilettantism. Yet you find vigour and conviction; its exponents, Picasso, Matisse, Derain, Balla, for example, are very considerable artists, very sure of themselves and of the claim of their business. So you get this contradiction of what is really a very great vitality in the visual arts, and at the same time a very serious scepticism and discouragement in the use of that vitality. How far is this the result of the obtuseness and the difficulties set up by the scratch-Public on which painters have to-day to rely? How far is it the result of a combination of the speculative agility of the dealer and of the technical agility among artists that is the flagrant result of the dissemination of second-rate wit?

°For this and subsequent notes, see the appendix of Explanatory Notes beginning on page 169.

Then the pleasant amateur (the vindictive failure of more settled and splendid ages) sees his chance. He drops down into the arena from among the audience, flourishing a red pocket-handkerchief, and by his pranks—some pseudo-professional, skipping like any Espada; some an impudent buffoonery—adds to the general confusion. The little bull laughs to see such sport, the crowds of degenerate and dogmatic Toreros, popping with pedantic mirth, tumble in imitation of the new-fangled clowns; the women hurl futurist° javelins torn from their hats, and transfix the bottoms of the buffoons and the billycocks of the banderilleros! The little bull, at first amused, eventually, at the end of the Corrida, expires of the most suffocating boredom, injected into him by a pale urchin with side-whiskers and a hooked nose. Is not that a fairly good picture of the bloody spectacle that we, Public and Performers, present?

It is evident that the Public is at fault. Why does it not insist on a better type of Bull in the first place, a more substantial type of art, that would be capable of driving all but the best performers from the Arena? If the public cannot think of a new type of Bull at the moment, and is not willing to take a new brand of beast that we are rearing on trust, let it at least put into the Circus some fine animal from Nineveh or rake the Nile valley for a compelling and petulant shape.

But the painter or sculptor, too, might give a hand, and the (I hide my face! I am almost too ashamed for him to utter his name) the Architect! Why does not the Architect (and every time I have to use that word I shall feel like apologising to you for mentioning such a poor, forgotten, jaded, lamentable creature!)—why does not this strange absentee, this shadow, this Ghost of the great Trinity, Sculpture, Painting, and Architecture—for which I have substituted Design, from a feeling of

comprehensible pudeur, in referring to this unfortunate Entity—*why does he not cheer us up by Building a New Arena?* Constructing around the new Bull that we are breeding our new, very active Art, a brand new and most beautiful Arena?

That question, I know, will remain unanswered. It is a tactless question, I admit. It is not at all nice, even, to refer to Architecture. You should say, perhaps, Usual Offices or something of that sort!

I have thought of a way out for the Architect. It has often been suggested of late that the Architect might become a branch of the Engineering industry. But why should he take all his bric-à-brac shop over to that clean, fresh, erect institution across the road? Rather let the Engineer and the Painter fix up a meeting and talk over the sadly-involved affairs of this decayed concern, which is, of all the scandals in the Art-World, the most scandalous and discreditable. The Painter and the Engineer could buy him out, going into partnership, and produce what would neither be a world of boxes on the one hand, as it would be if the Engineer controlled house construction (*vide* sky-scrapers), nor of silly antique fakes on the other, as happens when the Architect has his sweet and horrible way. Let us divide up this "ramshackle Empire" of Architecture. And we could even dispense with a Caliph. There need not be any bloodshed. It is a fair and smiling world!°

Now, of all painters who have ever breathed ponderously under a copper-coloured Vlaminck sky, the Cubist painters of Paris, the quantities of ponderous painters to be found cubing in that city, are the best fitted to fill this rôle—of superseding, in a practical liaison with the Engineer, the virtually extinct architect.

The energy at present pent up (and rather too congested) in the canvas painted in the studio and sold at the dealer's, and written of with a monotonous emphasis

of horror or facetiousness in the Press, must be released and used in the general life of the community. And from thence, from the life outside, it will come back and enrich and invigorate the Studio. When accepted, modern painting is accepted as a revolutionary oasis in the settled, dreary expanse of twentieth century commercial art: a place where bright colours, exciting and funny forms, a little knot of extravagant people, are to be found; and that it is amusing sometimes to visit. It was the same with the Impressionists: Whistler found himself beleaguered and interfered with in the same way: Gauguin and Van Gogh had the same experience. Listlessness, dilettantism is the mark of studio art. *You must get Painting, Sculpture, and Design out of the studio and into life somehow or other* if you are not going to see this new vitality desiccated in a Pocket of inorganic experimentation. And on the other hand, you must put the Architect, as he drags out his miserable if well-paid life to-day, into the dustbin, *and close the lid.*

When in the course of this pamphlet I speak of the "Movement in painting," or "Modern Painting," I mean all that is included by the practice of such diverse painters as, for instance, Derain, Matisse, Picasso, Kandinsky, or Survage.° These painters represent one aesthetic current in the sense that they are none of them Impressionists, have all one synthetic intention or another, and are all related roughly in time and in enterprise. The complete non-representative character of Kandinsky's painting, or the weightiness and palpable logic of the Cézanne-evolved Cubist, is really a portion of the same effort as that made by Derain or Matisse, who are neither Cubist nor Abstract. Survage's° mixed phantasy is the same.

There are bound to be within this great general movement many experiments and enterprises attempting to attract all the bulk of it in one direction or another. One

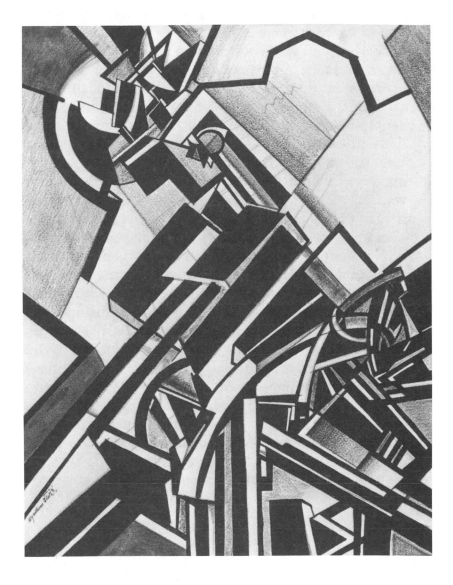

of the most powerful of these and one that has held the
stage for the last few years, is the Nature-morte develop-
ment of a group of Cubist painters, Picasso, Braque, and
Gris being three of the best known among them. Enter-
taining as some of these things are, I can see nothing
of permanent interest deriving from them. Meantime,
this exercise pursued for so long by these painters ap-
pears to me to denote a bad weak spot in the quarters
where it saw the light. Again, Picasso, great artist as
he is, and much as I admire him, looks to me rather
equivocal and unsatisfactory in the light of present
events. I devote considerable space to an adverse
analysis of this aspect of the general movement. But it
is because I believe so much in the wider movement,
and because the spirit of this Nature-mortism—also the
David-Raphael eclectic classic wave—contradicts what
I have written this pamphlet to propose, that I deal with
it so thoroughly. One other point in this preamble. I
have no fault to find with Cézannism. Any faithful
discipleship of that master is sure to be sound art. All
the same, Cézanne is such a lonely figure, and he has
such a weight of pups around him! No one man, even
a Cézanne, should have on his shoulders such a huge
effort of initiation as his was. There should have been
several men. Ungrateful as it seems, one must say that
it is a misfortune that all the diversity of art and human
talent of a generation should have depended on this one
old man, as has been the case, since he was unearthed.

THE CALIPH'S DESIGN

Architects! Where is your Vortex?

Part I
The Caliph's Design

THE PARABLE OF THE CALIPH'S DESIGN

ONE DAY THE CALIPH ROSE gingerly and stealthily from his bed of gold and placed himself at a window of his palace. He then took a pen of turquoise, and for some hours traced hieroglyphs on a piece of paper. They consisted of patches and lines, and it was impossible to say what he was doing. Apparently exhausted by the effort, he sank back on his bed of gold and slept heavily for ten hours. Waking up in the small hours of the morning, he called for a messenger and despatched him in search of Mahmud and Hasan, respectively the most ingenious engineer and the most experienced architect in his dominions. He was in fine fettle when they arrived. He pointed with a certain facetiousness to his design lying outspread on a table. He then addressed them as follows:—"I am extremely dissatisfied with the shape of my city, so I have done a design of a new city, or rather of a typical street in a new city. It is a little vorticist effort that I threw off while I was dressing this morning." He negligently curled the tip of his beard. "I want you to look at it and tell me what you think of my skill."

Mahmud and Hasan bent over the design, and, noticing that their lord's eye was dancing, they indulged in a few hurried guffaws, scraping their feet and pushing each other.

The Caliph then said, "Oh, Mahmud and Hasan, that

is a very funny design. But it is my will that such a street should rise beneath the windows of my palace, work starting on it at ten o'clock to-morrow morning. It is your unpleasant duty to invent the shapes and conditions that would make it possible to realise my design. You have till ten to-morrow morning in which to produce the requisite plans and instructions for such a work. Should you fail to do so your heads will fall as soon as I have been informed of your failure, that is to say, between ten and eleven to-morrow. Good-night, oh Mahmud and Hasan."

Those two tremendously able men burst into a cold sweat. Their eyes protruded from their intelligent faces. They clicked their tongues, shrugged their shoulders, and shuffled out with gestures of despair. After a half-hour of complete paralysis of their brilliant faculties, they pulled themselves together, and by ten o'clock next morning a series of the most beautiful plans that had yet been made in Baghdad (retaining with an exact fidelity the masses and directions of the potentate's design) were ready for their master. And within a month a strange street transfigured the heart of that cultivated city.

THE BULL SOUNDS

WE ARE ALL AGREED as to the deplorable nature of the form-content and colour-content around us.° But there agreement ceases.

The divergence of opinion gathers round the following points: Is it not preferable to have every manifestation of the vulgar and stupid constantly, in an appetising, delicious form (something like the "highness" of game), at the disposal of our superiority and wit?

What would Flaubert have done had France not bred Bouvards and Pécuchets with rabbit-like fecundity? Can nature ever be thanked enough for Sir Sampson Legend, Mantalini, Boswell's Johnson, Falstaff or any such types of Comedy, composed of the nastiest excrement and washiest imbecilities?° No one would diminish by one ounce the meat of art that resides in folly or deformity; or see snobbery, gluttony or cruelty reduced by one single exemplaire, once his mind was fixed on the benefits that the aesthetic sense has received from their abundance in Nature!

A less self-indulgent satirist like Aristophanes, it is true, will attach a stink or some disgusting attribute to his absurd character, relying on the squeamishness of his audience, sending his characters about like skunks. But most authors are not so moral as to poison our pleasure with these gases. A stupid form is for the painter the same food as a stupid man for a writer like Gogol or Flaubert.

So it is very debatable whether without the stimu-
lation of stupidity, or every bestial, ill-made, tasteless
object that abounds in life to-day, the artist would be
as well off and well nourished. Would he not be in the
position of a satirist, like Flaubert, without a Bouvard,°
or of an artist like Boswell without his rich and very
unusual dish? The irritation with the particular French
folly that surrounded him, and that Flaubert ate every
day as regularly as his breakfast; the consequent pessim-
ism that became the favourite manure for his thoughts;
we cannot see Flaubert without that, any more than we
can conceive of Rousseau the Douanier without his
squab little bourgeois, and blank, paunchy little villas.

The point rather lies in the *attitude* that was
Flaubert's and that was the Douanier's. Flaubert hated
Bouvard, and considered the vulgarity and idiocy that
he witnessed a very sad and improper affair. The Douan-
ier, on the other hand, probably admired his Bouvards
very much. It was with a naively respectful eye, it may
be assumed, that he surveyed the bourgeois on Sunday,
and noted his peculiarities like a child, directly, without
judging.

Shakespeare, it is true, must have relished the absurd
or deformed more consciously; and Dickens made a cult
of it. But with Shakespeare it was against a vast
background of other matter, and as comic relief, or used
in farces, and so labelled. It has never amounted to what
has practically become, in our day, a *rejection* of
anything as dull or useless unless it lends itself to our
appetite for the comic or the "queer."

But Wilde's° antithetic glitter, when used in jour-
nalism, may become the most wearisome thing on
earth. We long, confronted by such a monotony of in-
version as we get in Mr. G. K. Chesterton, for instance,
for a plain "dull" statement. In the same way, if the
villainous stupidity that has always been around every

man since the world began (only he has belaboured it with one hand while caressing it with the other) became something like the religion of the educated—such education, that is, as enabled you to enjoy it—and its pursuit and enjoyment the one topic and habit of life, should we not sigh for the old variety; the hero, the villain, the lovely lady and the Comic Relief? Should we not also, if embedded in some bric-à-brac of stuffed birds and wax flowers, and the languors of the "aesthetic period" of the article I cite later in this pamphlet, look towards Karnak, a plain French provincial town, or almost anywhere—with eyes of longing?

Surely all this sensibility of the "queer," the "amusing," the divinely ugly, the exquisitely vulgar, will date, and date very quickly.

There would to-day, in the "modern" section of the art-world, be as great an outcry if some philistine proposed that the lovely embellishments of our streets, coloured signs, posters, beautiful police-stations and bewitching tiled Tube stations should be pulled down, as there would have been formerly, and is still by the "beauty-loving public," when some "picturesque old bit" or decaying cottage is removed.

But, with men trying their hardest to eliminate ugliness, injustice, imbecility and so forth from the world, has there ever been any absence of these commodities for the sweet, or bitter, tooth of the artist? Is there ever likely to be? It is true that the artist can gorge himself to-day probably as never before. But is that the best thing for his talent?

If twenty Christs charged abreast anywhere in the world, you would still get in a remarkably short time, and within a half-hour's walk of their super-calvary, some such monument as the First Pyramid, the result of such a block of egotism as had never been seen before, to show you the weakness of the humane corrective.

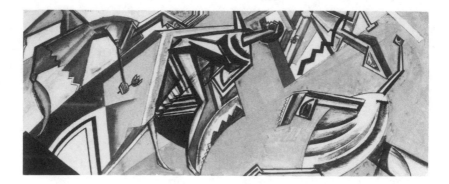

But I do not believe you would ever get a pyramid builder without Christian hysteria.

Even in order to appreciate the "banal" you must not have too much of it. And you must *pretend* you do not like it even if you are incapable of liking anything else. The reactionary Prussian theorists of war—good, beneficent war—tyranny, and so forth were less useful than the Pacifist, and less intelligent.

The arrangement seems to be that you spend half your time destroying the cheap, the foolish, the repellent; and the other half enjoying° what is left over after your efforts! This evidently being how we are intended to live, there is no excuse for slackness in the carrying out of your unpleasant duty: that is to desire equity, mansuetude, in human relations, fight against violence, and work for formal beauty, significance and so forth, in the arrangement and aspect of life.

But to conclude. The great line, the creative line; the fine, exultant mass; the gaiety that snaps and clacks like a fine gut string; the sweep of great tragedy; the immense, the simple satisfaction of the surest, the completest art, you could not get if you succeeded in eliminating passion; nor if you crowned imbecility, or made an idol of the weak.

Whereas you can always get enough silliness, meaningless form, vulgar flavour to satisfy the most gargantuan or the most exquisite appetite.

THE POLITICIAN'S APATHY

WHAT IS THIS UGLINESS, banality, and squalor to which we have been referring? It is simply what meets your eye as it travels up practically any street in London to-day, or wanders around any Hotel lounge or Restaurant, or delects itself along the wall of the official galleries at Burlington House.° Next, what influences go to the making of this horrible form-content and colour-content that we can either offer up a prayer of thankfulness for, take no notice of, or occupy ourselves with modifying, in our spare time? Exactly what set of circumstances, what lassitude or energy of mind working through millions of channels and multitudes of people, make the designs on match boxes (or the jokes on the back of some), the ornamental metalwork on the lamp-posts, gates, knife-handles, sepulchral enclosures, serviette-rings, most posters, ornamented Menu cards, the scenery in our Musical spectacles, chapter-headings and tail-pieces, brooches, bangles, embossments on watches, clocks, carving-knives, cruets, pendants in Asprey's, in Dobson's, in Hancock's windows in Bond Street; in fact, every stitch and scrap of art-work that indefatigably spreads its blight all over a modern city, invading every nook, befouling the loveliest necks, waists, ears, and bosoms; defiling even the doormat — climbing up, even, and making absurd and vapid the chimney pot, which you would have thought was

inaccessible and out of sight enough for Art not to reach; for the cheap modern thousand-headed devil of design not to find it worth while to spoil?

We are all perfectly agreed, are we not, that practically any house, railing, monument, wall, structure, thoroughfare, or lamp-post in this city should be instantly pulled down, were it not for the "amusement" and stimulus that the painter gets out of it?

A complete reform (were it not for the needs of the painter who *must* have his bit of banality, bless his little heart!) of every notion or lack of notion on the significance of the appearance of the world should be instituted. A gusto, a consciousness should imbue the placing and the shaping of every brick. A central spectacle, as a street like Regent Street° is, should be worked out in the smallest detail. It should not grow like a weed, without forethought, meaning, or any agency but the drifting and accident of commerce. A great thoroughfare like Regent Street develops and sluggishly gets on its ill-articulated legs, and blankly looks at us with its silly face. There are Bouvards and Pécuchets in brick and stone, or just dull cheerless photographs. There is no beautiful or significant relief, even, in this third-rate comic spectacle.

Do politicians understand so little the influence of the Scene of Life, or the effect of Nature, that they can be so indifferent to the capital of a wealthy and powerful community? Would not a more imaginative Cecil Rhodes° have seen that the only way an Empire such as he imagined could impress itself on the consciousness of a people would be in some such way as all ambitious nations have taken to make the individual citizen aware of his privileges and his burden? Whether in the weight of a Rhetoric of buildings, or in the subtler ways of beauty signifying the delights and rewards of success won by toil and adventure; in a thousand ways the

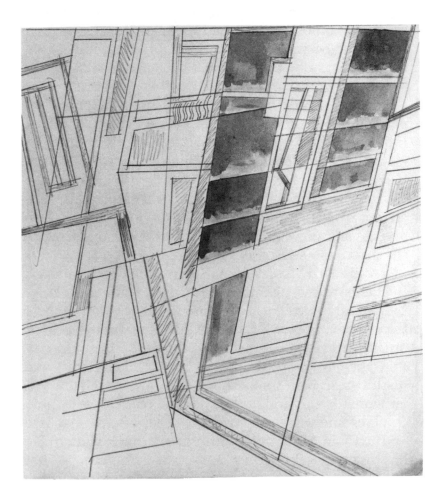

imagination of the multitude could be captured and fixed. But beyond the obvious policy of *not* having a mean and indolent surrounding for the capital of what sets out to be an "Empire," simply for human life at all, or what sets out to be human life— *to increase gusto and belief in that life*— it is of the first importance that the senses should be directed into such channels, appealed to in such ways, that this state of mind of relish, fullness and exultation should obtain.

It is life at which you must aim. Life, full life, is lived through the fancy, the senses, consciousness. These things must be stimulated and not depressed. The streets of a modern city are depressing. They are so aimless and so weak in their lines and their masses, that the mind and senses jog on their way like passengers in a train with blinds down in an overcrowded carriage.

This is worse, again, for the crowd than the luckier individual. The life of the crowd, of the common or garden man, is exterior. He can only live through others, outside himself. He, in a sense, *is* the houses, the railings, the bunting or absence of bunting. His beauty and justification is in a superficial exterior life. His health is there. He dwindles and grows restless, sick and troublesome when not given these opportunities to live and enjoy in the simple, communal crowd manner. He has just sense enough to know that he is living or not living. Give him a fine, well-fed type of life, a bit dashing and swanky, suitably clothed, with a glamour of adventure about it, to look at, and he is gladdened, if his own stomach is not too empty. Give him fine processions, and holidays, military display. Yes, but there is something you are going to omit. By the deepest paradox he knows that the plaster objects stuck up in Oxford Street outside Selfridges for Peace Day are not a symbol of anything but commerce; in which he equally, though not so successfully, is engaged himself.

There is nothing there that he could not do himself, and they do not reach his imagination. Similarly, it is not such a tremendous critical flight as you would imagine for him to connect in some subtle way in his mind these banal plaster statues with the more careful but even more effusively mean Albert Memorial,° or any other monument that meets his eye. Yet these he knows are the monuments that typify the society of which he is a unit. This putrid dullness, hopeless deadly stare of almost imbecile stupidity, that he is confronted with in the art offerings from those above, as in their persons, can hardly be expected to stimulate him, either to buoyancy, obedience, or anything but boredom.

So if there are a hundred reasons why Painters should oppose any modification of the appearance of our world,° which is *Perfect* in the quaintness of its stupidity, there is no reason why the politician should feel obliged to protect it.

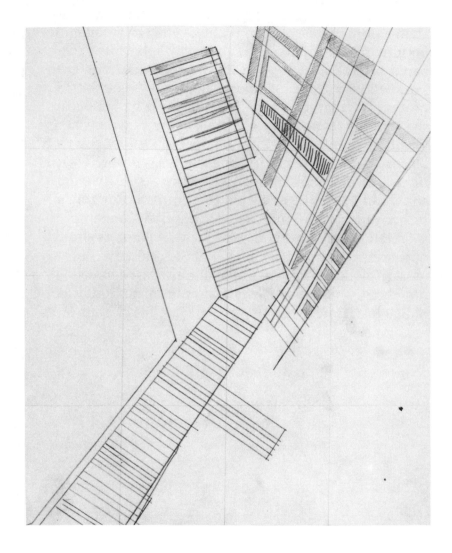

HOW THE FACT OF STYLE OBSTRUCTS

THE PARABLE OF THE CALIPH'S DESIGN describes the state
of mind which must be that of every healthy and active
artist living in the midst of the blasphemous stupidity,
too much so even for health, that surrounds us to-day.
But alas! although like the Caliph, a vorticist, I have
not the power of life and death over the Mahmuds and
Hasans of this city. Otherwise I should have no com-
punction in having every London architect's head
severed from his body at ten o'clock to-morrow morn-
ing, unless he made some effort to apply a finer stan-
dard of art in his own art-practise. I would flood those
indolent commercial offices, where architects pursue
their trade, with abstract designs. I am sure the result
would be to cram the world with form and intention,
where to-day, as far as it is beholden to the architect,
it has no discernible significance or aesthetic purpose
of any sort.

There is no reason at all why there should not be a
certain number of interesting architects. I can also see
no reason why this pamphlet should not bring them
forth. I should be very proud of that, and watch their
labours with great interest. This, I think, is such a
modest optimism that I am sure you will allow it. I
should like to see the entire city rebuilt on a more con-
scious pattern. But this would automatically happen
should an architect of genius turn up who would invent

an architecture for our time and climate that was also
a creative and fertilising art-form. The first great modern
building that arose in this city would soon carry
everything before it; and hand in hand with the engineer,
and his new problems, by force of circumstances so
exactly modern ones, would make a new form-content
for our everyday vision. So all we want is one single
architect with brains, and we will regard him with
optimism.

Now the question of form-content is obviously one
of importance to every painter. Almost any painter,
sculptor, or designer of an actual type to-day will agree
with you that Cheapside, Piccadilly, Russell Square,
Marylebone Road, are thoroughly dull and insignificant
masses of brickwork, laid out according to no coherent
plan, bestially vulgar in their details of ornament, and
in every way fit for instant demolishment. Similarly,
he will agree that any large and expensive West-End
restaurant is an eyesore, and a meaningless sham.

Similarly, when you say to him that it is about time
something were done to get rid of this graceless and
stupid spectacle, he will agree, but will quickly change
the subject. Every law of common-sense precludes any
possibility of an appreciable modification of this
detestable sight. He will either imagine that you are out
for some Utopia, or he will think that your notions
hardly agree with the fashionable fad-idea that all is for
the best in the best of all possible worlds—that whatever
reality, accident, or your neighbour, that is, flings at
your head, your head should resound to, if it is empty,
as it ought to be.

Of course there are good arguments against you. I have
made use of those arguments myself. We have just been
envisaging them in the section of this pamphlet headed
"The Bull Sounds." But we will proceed to sift out
more thoroughly the Painter's argument; this time not

only the painter or the amateur, but any painter.

Style, he will say, can transform anything into gold. Take a convenient example. Should Rembrandt in one of his pen-drawings have had a more interesting type of architecture before him for subject matter, in place of the country mills by the side of the Dutch canals, would this better form-content have made his drawings better drawings? You must answer to that: "No, it would not." But a windmill is a rough and simple contrivance, and there is a sad difference between the rough beauty and fitness of such objects stuck up centuries ago in Holland, and similar rough and simple objects built to-day. One would do better to imagine a Rembrandt, working in the same way that he worked, doing similar drawings in an industrial country like England or Germany at the present time. Still you have to admit that as fine an artist as Rembrandt would, by the magic of his use of the medium he chose, by his line, by his tact of simplification and elimination, make a *New* thing of anything, however poor the original.° And so, in considering if it is worth while to change a single brick, even, or the most trifling ornament, however offensive, you would be compelled to admit that, as regards the production of the finest type of art you would be no better off. The best half-dozen artists of any country, as regards the actual beauty and significance of their work, do not depend on the objective world for their success or stimulus.°

As to all the thousands of artists, not amongst the most able or imaginative, but possibly able to do something, it is another story. *They* depend on Nature, on the objective world, for their stimulus or their taste. Set a rather poor artist down in a roadway, ask him to draw a street of houses in front of him. If the houses were of a good and significant build, he would be more likely to do a good and significant painting than if they

were such clumsy, and stupid, lineless, massless, things as we invariably find ourselves in the midst of to-day. If he has no particular invention or vision of his own, he depends on Nature a good deal. Nature must do half the work.

But the fallacy in the contention about a good artist is this. That although he does not depend on Nature, he certainly depends on life, and is subject to its conditions. And this surely re-acts on his painting. If he starves, is disturbed in his work, or has to do some horrible type of present-day commercial painting or designing to make a living, then his independence of objective form and colour-content is of little use to him.

WHERE THE PAINTER WOULD BENEFIT

APART FROM MY CONVICTION on this subject, a useful way of illuminating it will be to consider how I, or an artist like me, stands towards it on the practical ground. It reduces itself to this: I have nothing materially to gain by your adopting these theories. You are perplexed: painters are everywhere perplexed. I make you and them a present of this analysis of these perplexities. I see the shapes that you would see did the world for the moment contain more stimulation and effort in the related arts. I do not need to have a house built with significant forms, lines, masses, and details of ornament, and planted squarely before my eyes, to know that such significance exists, or to have my belief in its reality stimulated. But *you* require that. I am, or any painter you can see is, obviously here to do that. I am at your disposal in this respect. But that is primarily a work for you and not for me. I can get on quite well, the artist always can, without this material realisation. Theoretically, even, a creative painter or designer should be able to exist quite satisfactorily without paper, stone or paints, or without lifting a finger to translate into forms and colours his specialised creative impulse. It should be the same with the painter, the architect, or the sculptor as it is with the composer of music. The Interpreter is really only in the same category as the bricklayer, or at best a foreman of works.

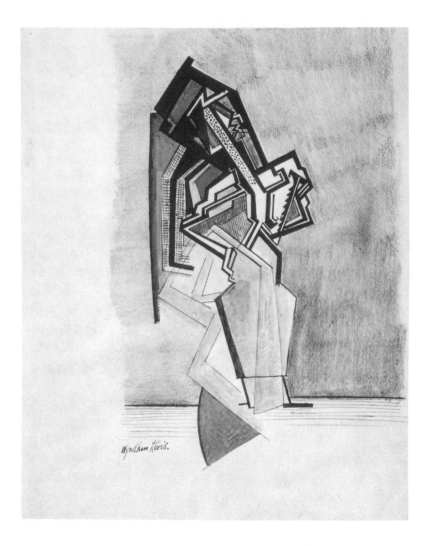

Still, I suffer somewhat all the same, from this lack of readiness, or really of aptitude, on your part, to employ me usefully. And every true artist I know, painter or sculptor, is in the same box. The trouble is this: It does not matter what objective Nature supplies. The inventive artist is his own purveyor. But the society of which he forms a part, can, by its backwardness, indolence, or obtuseness, cause him a series of inconveniences; and above all, can, at certain times and under certain conditions, affect his pocket adversely and cause him to waste an absurd amount of time. When no longer able to produce his best work, it would not be a waste of time for a painter or for a writer to lecture, for example, on the subject of his craft. The propaganda, explanatory pamphlets, and the rest, in which we, in this country, have to indulge, is so much time out of active life which would normally be spent as every artist wishes to spend his time, in work, in a state of complete oblivion as regards any possible public that his work may ever have. Yet were one's ideas on painting not formulated, and given out in the shape of a lecture, a pamphlet, or a critical essay, an impossible condition would result for an artist desirous of experimenting.

So when I say that I should like to see a completely transfigured world, it is not because I want to *look* at it. It is *you* who would look at it. It would be your spirit that would benefit by this exhilarating spectacle. *I* should merely benefit, I and other painters like me, by no longer finding ourselves in the position of freaks, the queer wild men of cubes, the terrible futurists,° or any other rubbish that the Yellow Press invents to amuse the nerves of its readers. (Do you suppose that the art-man who reports on the French Show in Tottenham Court Road° and describes the "horror" of these pictures, really *thinks* that they are in any way blood-curdling? No. He knows for every extra curdle he makes an extra

quid.) It naturally does not please me, or any other painter who paints pictures that appear extravagant according to the pretty and facetious standard of this time, to be described as a wild man, or a bolshevik in paint. No pleasurable thrill accompanies these words when used about one's own very normal proceedings, since they appear to the painter the *only* normal proceedings in the midst of the detestable capers of the usual mild lunatic asylum we have to inhabit.

THE PUBLIC CHOSEN

THE PUBLIC I SHOULD LIKE for this pamphlet is a rather different one than that to which painters usually consider it worth while to address themselves. In the first place, any individual belonging to the rank and file of the Royal Academy is fond of regarding himself as "a Craftsman"; as a specialist of the most prodigious, horny, paint-and-dust-grimed, mediaeval sort. The more furibundly ignoble his paintings, the further he retires into the technical mysteries of his craft. And so lay opinion he scorns.

Then another pale exists, an even funnier one, beyond which stand those multitudes who have not been taught a delightful faintness, a cheap catch of the voice, and the few dozen snobbish tricks of thought and hand coined in each decade for the lucky young rich. A board school master, an excise clerk, a douanier, for that matter, are usually approached if at all with every nuance of amused condescension that a disgusting stereotyped education can breed.

How sick such men must be with the wearisome and endless trifling that they have come to associate with the word Artist!

I write in these notes for a socially wider and not necessarily specialist public.°

ARCHITECTURE

ARCHITECTURE IS THE WEAKEST of the arts, in so far as
it is the most dependent on the collective sensiblity of
its period. It is so involved, on the other hand, in utili-
ty, and so much a portion of public life, that it is far
more helpless than painting and literature in the face
of public indifference. Sculpture shares with it some of
this helplessness. There are many good sculptors wasted
to-day as thoroughly as anyone can be, through the
absence of such conditions as are needed to give them
their chance of natural expression. Had Gaudier-Brzeska
lived, he would be doing an odd door-knocker or two,
and an occasional paper-weight, or portrait busts, for a
living, with all the limiting circumstance that personal
vanity sets to that form of art work. There only remains
for the sculptor, as for the painter, the art exhibition,
and the freak-selling or commercial-selling of the
dealer's shop. A man like Archipenko,° for instance,
quite capable of finer things, is reduced to stunt-
sculpting of a dilettante sort, on a small scale, it may
be assumed of a precarious nature on the material side.

Have you ever met an Architect? I do not mean a well-
paid *pasticheur*, who restores a house or runs one up,
in Tudor, Italian, or any other style. But a creative archi-
tect, or a man with some new power in his craft, and
concerned with the aesthetic as well as the practical
needs of the mass sensibility of his time? I have not.

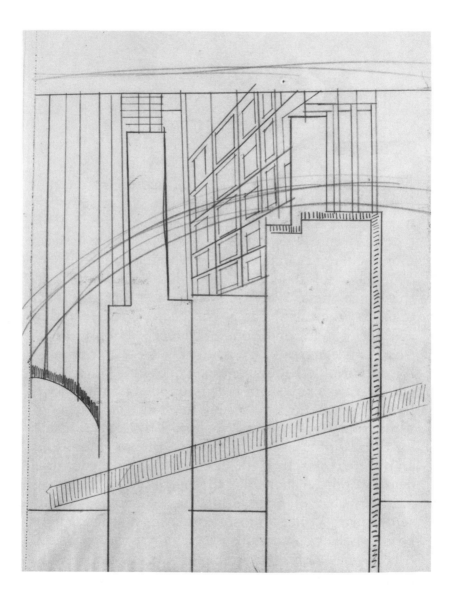

And what is more, should you wish to approach this neglected subject and learn more about it, you will find nothing but a dismal series of very stupid books for your information and reference. The best treatise I have so far come across is W. K. Lethaby's handbook, "An Introduction to the History and Theory of the Art of Building."° It appears to me to be as sound a book as possible: and if everybody were of Mr. Lethaby's opinions we should soon find that the aspect of this lifeless scene had changed for the better. And this voice for the right and active vision comes from the unlikeliest quarter. For Mr. Lethaby, I understand, is Chief Lecturer on Architecture in the South Kensington School.

Listen to this admitted academic authority on the subject:

> Modern armoured concrete is only a higher power of the Roman system of construction. If we could sweep away our fear that it is an inartistic material, and boldly build a railway station, a museum, or a cathedral, wide and simple, amply lighted, and call in our painters to finish the walls, we might be interested in building again almost at once. This building interest must be aroused.
>
> We cannot forget our historical knowledge, nor would we if we might. The important question is, Can it be organised and directed, or must we continue to be betrayed by it? The only agreement that seems possible is agreement on a scientific basis, on an endeavour after perfect structural efficiency. If we could agree on this we need not trouble about beauty, for that would take care of itself.
>
> Experiment must be brought back once more as the centre of architecture, and architects must be trained as engineers are trained.
>
> The modern way of building must be flexible and vigorous, even smart and hard. We must give up designing the broken-down picturesque which is part of the ideal of make-believe. The enemy is not science, but vulgarity, a pretence to beauty at second hand.°

What do you make of that? Does not Mr. Lethaby, Professor of Architecture in the South Kensington Schools, speak to you in a tone seldom heard in the art-schools? What English professor of painting would you find recommending his pupil to paint in a manner "smart and hard"?

Such books as C. H. Caffin's° contain nothing very useful. He refers to the Woolworth Building in New York in the following way:

> Up to the present, the noblest example of this new movement is the Woolworth Building, which is not only the tallest of the tall buildings, but a monument of arresting and persuasive dignity. Such a building supplies an uplift to the spirit. [Etc.]

The Woolworth Building, one of the tallest in New York, consisting of 51 storeys, is a piece of rudimentary ecclesiastical nonsense, 25 of its storeys being a spire.° It is in every way less interesting than the less ambitious sky-scrapers, which are at least enormously tall boxes, and by their scale "uplift the spirit" that wishes to soar so high, far more than this monstrous, dull, Anglican church: that is not a church, however, and has not even that excuse for its stupid spire.

In this connection, we hear a great deal of rubbish talked about the sky-scraper. The sky-scraper, for the most part, is a tall box. So far it has been nothing but that; except where, as in the Schiller Theatre Building° in Chicago, or the famous Woolworth Building, some dreadful intervention of art has converted it into an acre-high advertisement of the modern architect's fatuity.

It has been a fashion lately to admire the sky-scraper in its purely engineering form, and other forms of quite plain engineering construction. But a box is always a box, however high. And when you think of the things that could have been done by a liaison of the artist's

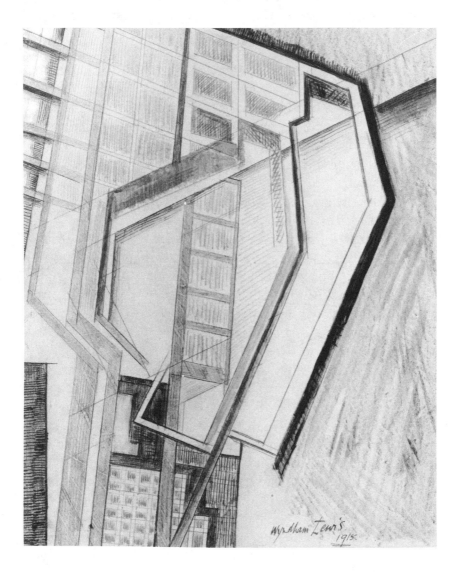

fancy, once more, with all these works of engineering genius, you wonder that there is not one single example which one can quote of such a structure.

In the case of a dynamic shape like an aeroplane there is neither any reason nor any need for the association of engineering inventiveness with that of the artist. All such machines, except for the colouring of them and a possible deliberate camouflaging to modify their shape, not to deceive the eye of the enemy but to add significance or beauty to their aspect, develop in accordance with a law of efficient evolution as absolute as a tiger, a wasp, or a swallow. They are definitely, for the artist, in the category of animals.

When we come to the static cell-structures in which we pass our lives there is far more latitude and opportunity for the inventiveness of the artist.

To begin with, let us by all means reduce everything to the box. Let us banish absolutely the stylistic architectural rubbish. But even as to the shaping of the box or series of boxes let the artist be used.

For if you say that the design and ornament over the body of the building is the same as the clothes on a man's back, there is still something to be said about the naked shape of the man or even for his skeleton. The nature of the body or of the skeleton will decide what the character of the clothes must be. So the artist should come in long before he usually does, or give a new consciousness to the shaping of the skeleton of the Engineer. This should be invariable, not occasional: that is when the first painters or sculptors have been used for this purpose, instead of the horrible stock architect.

Remy de Gourmont° has the following notion on the subject of the decay of architecture in our time:

> Voilà le point capital de l'explication pourquoi on avait au moyen-âge le sens de l'architecture: on ignorait la

nature. Incapables de jouir de la terre telle qu'elle est, des fleuves, des montagnes, de la mer, des arbres, ils étaient obligés, pour exciter leur sensibilité, de se créer un monde factice, d'ériger des forêts de pierre.

La nature s'ouvrit à l'homme parce que la France et le centre de l'Europe furent sillonnés de routes, parce que les campagnes devinrent sûres et d'un commode accès.

And he goes on to fancy that perhaps when Nature has become too cheap, through its general accessibility, and men tire of it, that Art and Architecture will once more have its turn.

Since a narrow belt of land like the Nile valley is more crowded with buildings, or their remains, than any other territory, and since the character of those buildings, the source of all subsequent constructions, was evidently determined by the nature of the landscape of Egypt, the hills, palms, and so forth, with which, further, the builders were at least as familiar as any men could be with Nature, de Gourmont's theory would appear to be nonsense. It displays the listless and dull eye that a usually keen journalist can turn to this Cinderella of a subject.

CHILD ART AND THE NAIF

THE CHILD AND THE NAIF ARE TWO of the principal mainstays of dilettante criticism in this country. And this "phenomenon" with all the sentimentality of which its exploitation clearly is susceptible, is one of the trump cards in the Amateur's game, and a fruitful source of confusion. It is one of the most obvious avenues, flooded with an effusive critical craft, by which the thoroughly undeserving can slip through into a position of artificial respect.

"The Young Visiters" is swelling into fabulous editions. Pamela Bianco, a child of nine, is fawned on by the hoary great. The Omega Workshops have had an exhibition of children's drawings.° The Naif, too, is a doll-like dummy that the trader on sentiment pushes in front of him in stalking the public. The Naif is an elastic phenomenon and of earlier date, as regards his boom, than the Child.

The Slade School° produces regularly a certain number of naifs. They are frequently the most sophisticated individuals imaginable. Beyond the fact that they wrestle with a slight incompetence, in addition to possessing a pretty feeling for the sentimentalities of rustic prints, although they never by any means capture the native charm of those, they are no more naive than Mr. Horatio Bottomley.° None that I know are half as good manufactured naiveté as George

51

Formby.° They are very cunningly simple, and their graces and queernesses pall as swiftly as the tiresome mannerisms of a too clever child, exploiting its childishness.

There are two types of Naif: the Child-Naif, and the Primitive Naif. It is difficult to decide which is the more boring of the two.

The Child-Naif usually starts from a happy combination of an ingrained technical incompetence and of a "nice feeling" for the things of art. He is distressed that this "nice feeling" should be wasted owing to his lack of power, and hits on the happy idea, or gradually drifts into the habit (a sort of progressive *collage*) of bringing his lack of painter's prowess and his nice feeling for art together, and producing the very marketable commodity, Naiveté!

Or he may be a bit more definitely naive than this. The woodenness of his figures or trees, his rickety line, may really have a pathetic charm for him. He genuinely pities his little wooden figures for being so wooden and silly looking (a manner of pitying himself). He is sorry for himself through them! And this sensation becomes a necessity with him; he goes on doing them. If he has been touched enough; or, more likely, if his is a nasty theatrical self-love, other people are touched, and he in turn touches a little regular income in consequence!

Or the more general pathos may be absent. The weak pathetic line, and silly meaningless forms, the unreal colour, are the object of a certain emotion: something that I can only describe as a technical pity; a professional pathos. The best is made of an unfortunate limitation. This Naif may even become perfectly bumptious and self-satisfied in course of time, everything turning out, in the practical sphere, for the best: by the same process that produces the infantile swank of the deformed.

The Primitive Naif may evolve rather in the same way as the Child-Naif, or he may not. It may be a refuge of incompetence. Or it may be a romantic mode, teutonic in character. Then the Child-Naif and the Primitive Naif sometimes come together in the same artist.

There is no such thing as the *born Primitive.* There is the *Primitive* in point of view of historical date, the product of a period. And there is the *Primitive voulu*, who is simply a pasticheur and stylist, and invariably a sentimentalist, when not a rogue. When he is not specially an *Italian* or *Flemish Primitive,* but just a *Primitive* (whatever period he flits into *always* a Primitive), he is on the same errand and has the same physiognomy as the Period-taster, or any other form of dilettante or of pasticheur. The Primitive voulu acrobatically adapts himself to a mentality of a different stage of social development: the pasticheur merely, en touriste, visits different times and places, without necessarily so much a readjustment of his mind as of his hand.

As to the Child proper. Of course the success of "The Young Visiters" is partly due to its domestic appeal, partly due to its character of a sentimental curiosity. The distillation of Middle-class snobbery, also, presented in this pure and objectionable form, is sure to "attract a wide public."

Pamela Bianco, whose drawings are to be found in a publication called the *Owl,* in *Vogue,* and so forth, is like Daisy Ashford at least in one point: that *she is not a child.* She may be nine years old, and "The Young Visiters" may have been written by a child of two. But they both have every sad relaxed quality of the average adult mind. They are as extinct as that. Pamela Bianco's "libido"° has naively devoured the Douanier's Fête National. But that is the nearest she has come to

naiveté. Otherwise she imitates Beardsley or Botticelli, or some fellow-child, with as sophisticated a competence as any South Kensington student. She is very exactly the aesthetic peer of the professional painters who run the *Owl*.

The growth of the mind and of the body is so often not parallel, some people's "mature" lives so long, others almost non-existent, that it is difficult to know where you are dealing with the art product of the child, or the child-like art of the adult.

Presumably a powerful nature develops at once, disregarding the schedules of human growth and the laws of probation. William Blake was a case of a being who took little notice of the dawdling ritual of growth. On the other hand, many individuals, highly developed in adult life, have shown no precocity at all.

Genius no doubt has its system of working in a man, all the facts of the case—the best time to strike—the mental resources—the character of the gift to be hatched—in its possession.

As regards the Naif, Rousseau the Douanier is the only great naif as far as I know. In his case Nature made on the one hand his Douanier's calling a water-tight case against sophistication; and then put something divinely graceful and simple—that we associate with "childhood" and that that abstraction sometimes has—at his disposal for the term of his life.

Nothing seemingly could corrupt or diminish it; and it brought with it, like a very practical fairy, or a sardine tin with its little key, an instrument with which to extract all the genius from within this Douanier of forty or fifty years old.

To return to the Child proper. The only case in which the drawing of a child is of value, is when it possesses the same outstripping or unusual quality that the work of a very few adult artists possesses. The adult in

question may have accomplished nothing himself as a child. But the drawing of the child would seem perhaps to be his work at a more immature stage. It is not a question of Child or Adult. It is a question simply of the *better being.* Both belong to an exceptional type of being.

There is also a fresh and delicate charm of very young life that some children, not many, have the power of infusing into their drawings. And there remains the melancholy fact that no infant's pictures could be duller than the average adult's. And therefore there is every bit as much justification for exhibiting any twenty children's scribbles as there is for exhibiting those of any twenty professional painting adults.

MACHINERY AND LIONS

THE FUTURISTS HAD in their idée fixe° a great pull over the sentimental and sluggish eclecticism, deadness and preciosity of the artists working in Paris.

But they accept objective nature wholesale, or the objective world of mechanical industry. Their paean to machinery is really a worship of a Panhard racing-car, or a workshop where guns or Teddy bears are made, and not a deliberate and reasoned enthusiasm for the possibilities that lie in this new spectacle of machinery; of the *use* it can be put to in art. Machinery should be regarded as a new resource, as though it were a new mineral or oil, to be used and put to different uses than those for which it was originally intended. A machinery for making the parts of a 6 in. Mk. 19 gun should be regarded apart from its function. Absorbed into the aesthetic consciousness it would no longer *make* so much as a pop-gun: its function thenceforward would change, and through its agency emotions would be manufactured, related, it is true, to its primitive efficiency, shinyness, swiftness or slowness, elegance or power, but its meaning transformed. It is of exactly the same importance, and in exactly the same category, as a wave on a screen by Korin, an Odalisque of Ingres, a beetle of a sculptor of the XVIII dynasty. Ingres lived in the midst of a great appetite for the pseudo-classic: the Egyptian sculptor lived in the presence of a great

57

veneration for the beetle. Korin's contemporaries possessed a high susceptibility and sentiment for the objects of the natural world. Korin's formal wave-lines° is the same impulse as Balla's Linee Andamentali:° the Beetle and the Odalisque are both sleek and solid objects! Ingres probably did not believe in the Odalisque as an Odalisque, although realising the admirable uses to which she could be put. The Egyptian probably found the beetle objectionable until transformed into stone. And there should be no obligation to supply veneration, or to behave like a religious fanatic about a sausage machine or a locomotive: other people can supply that, indeed should do so about something or other. If the world *would only build temples to Machinery* in the abstract then everything would be perfect. The painter and sculptor would have plenty to do, and could, in complete peace and suitably honoured, pursue their trade without further trouble. Else what is the use of taking all the useful Gods and Goddesses away, and leaving the artist with no rôle in the social machine, except that of an entertainer, or a business man?

Imagine Koyetzu, Signorelli,° or the sculptor who carved the head of Akhenaton or of the wife of the Sheik-el-Beled, alive painting and carving, to-day. They would have been in the profoundest sense the same artists. But just as a painter may use one medium one day and another the next; so far more than simply traces of the fact that they had seen the machines that play such a part in our existence would be found in their inventions. Just as the sculptors of Nineveh put the lions that were such immediate objects in their life, to good use in their reliefs; or the painters of the Sung period° the birds and landscapes found by them in their wilfully secluded lives; so it was inevitable to-day that artists should get into their inventions (figures, landscapes, or abstractions) something of the lineaments and character of

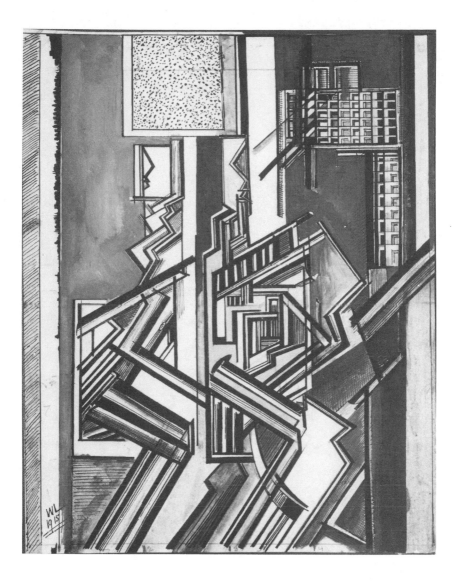

machinery. An artist could excel, no doubt, who never suggested in his pictures acquaintance with anything more ferreous than a mushroom. But you would not be liable, I suppose, to pick a quarrel with the artists of Asshur because they used the lions at their door?°

This ground has to be gone over, and thus much reasserted, for the purposes of the new adjustments I propose.

THE ARTIST'S LUCK

THE BEST ARTISTS OF THE SUNG PERIOD lived a secluded life, very luckily for them. It was considered the thing to inhabit the fairly distant country and live in intercourse with the objects of Nature. When this fashion passed, and a painter had to live within hailing distance of the court, the pictures produced showed an immediate decline in quality. That is *one* lesson.

The scenes in the Assyrian bas-reliefs from Nineveh were produced by an artist who led an unlucky kind of life. He was hurried about by the king in his razzias and hunts: no sooner had the party (a marauding or a hunting one) returned to the city than the harassed sculptors had to rush to their workrooms and produce by the next morning a complete series of bas-reliefs describing in what was apparently considered a flattering way the exploits of their diabolical idiot of a master. For no sooner had he slept off the fatigue caused by the last of an incessant series of displacements than he insisted on seeing what he had looked like to his band of performing sculptors during the last week or two. Their heads probably fell like apples in an autumn wind; though there is seemingly no record of his ever having had sculptors enough to build up their skulls into a pyramid. How they succeeded in doing such good lions it is difficult to say. Perhaps the ones who did the good lions were left in peace sometimes. But on the whole, a sculptor

fated to work for Asshur's deputy would no doubt have regarded the Sung hermit as the luckiest old yellow crab that ever painted.

It has occurred to me that we might be worse off than we are. But I can see no reason why we should not be better off: hence, partly, this pamphlet.

Part II
The Artist Older than the Fish

THE ARTIST OLDER THAN THE FISH

THE ARTIST GOES BACK TO THE FISH. The few centuries that separate him from the savage are a mere flea-bite to the distance his memory must stretch if it is to strike the fundamental slime of creation. And it is the condition, the very first gusto of creation in this scale of life in which we are set, that he must reach, before he, in his turn, can create!

The creation of a work of art is an act of the same description as the evolution of wings on the sides of a fish, the feathering of its fins; or the invention of a weapon within the body of a hymenopter to enable it to meet the terrible needs of its life. The ghostly and burning growths, the walking twigs and flying stones, the two anguished notes that are the voice of a being, the vapid twitter, the bellows of age-long insurrection and discontent, the complacent screech, all may be considered as types of art, all equally perfect, but not all equally desirable.

The attitude of instructed people as regards "the artist" has changed. It is mixed up with, and depends a good deal on, the exactitude of their application of this term. With the grotesque prostitution of the word Artist, and its loose, indeed very loose and paltry meaning in this country, I will deal in a separate section. A German philosopher, living in the heyday of last century German music, accepted the theory of an aesthetic

justification of the universe.° Many people play with
this notion, just as they play with Art. But we should
have to disembarrass "art" of a good deal of cheap
adhesive matter, and cheap and pretty adhesive people,
before it could appear a justification for anything at all;
much less for such a gigantic and, from every point of
view, dubious concern as the Universe!

The artist's function is to create — to make something;
and *not* to *make something pretty*, as dowagers,
dreamers, and dealers here suppose. In any synthesis of
the universe, the harsh, the hirsute, the enemies of the
rose, must be built in for the purposes as much of a fine
aesthetic, as of a fine logical, structure. And having
removed the sentimental gulf that often has, in the
course of their chequered career, kept Sense and Beauty
apart, we may at this stage of the proceedings even refer
to their purposes as one.

Fabre° describes the creative capabilities of certain
beetles, realisable on their own bodies; beasts with a
record capacity for turning their form and colour im-
pulses into living flesh. These beetles can convert their
faces into hideously carved and detestable masks, can
grow out of their bodies menacing spikes, and throw
up on top of their heads sinister headdresses, overnight.
Such changes in their personal appearance, conceived
to work on the psychology of their adversaries, is
possibly not a very profound or useful invention, but
it is surely a considerable feat. Any art worth the name
is, at the least, a feat of this description. The New
Guinea barred and whitewashed masks are an obvious
parallel. But any invention or phantasy in painting or
carving is such. As to the wing mechanism that first
lifted a creature off the ground, and set it spinning or
floating through the air, you must call Shakespeare in
to compete with it. Ma Yuan we can consider, roughly
speaking, as the creator of the first tree; or substitute

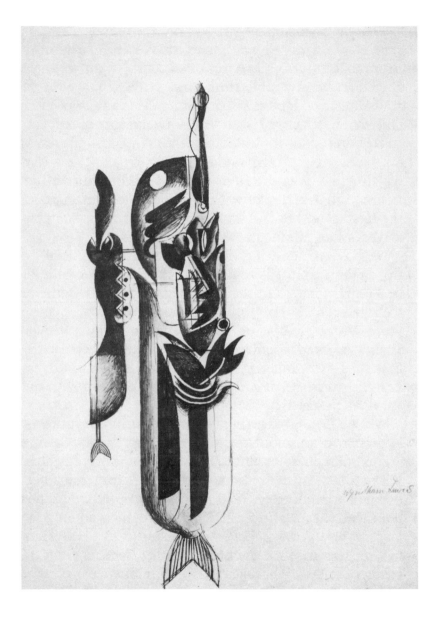

for him the best artist, who has painted the best tree, that you can remember.°

The more sensible we grow about the world, the more sensible we grow about the artist. We are really more in sympathy with a bird or a fish to-day than we have been for a considerable time. And while people at large are being forced, by snobbery, into a less anthropomorphic mood, they find, with some awakening of respect, traces and odd indications of the artist's presence everywhere they go beyond their simian pale. The artist, we all agree, was the first scientist! His "inhumanity" is so old that he looks with considerable contempt on the upstart and fashionable growth that the last twenty years has produced!

We have got out of our anthropomorphism, then, to this extent: that it is to-day in reality as respectable to be a fish, as it was in the latter part of the last century to be a savage. The Robert Louis Stevenson, George Borrow, "back to Nature" Englishman (not an artist type at all) is as dead as a doornail.° It is the artist type, even, that has prevailed in the philosopher's mind, its dogmatism correcting itself by a careful liaison with the spirit of the artist.

We no longer dream about earlier communities, knowing more about them, or long for some pristine animal fierceness or abundant and unblemished health. We realise how every good thing dates, and grasp better the complexities of life's compensations. That does not mean that we are satisfied with to-day's conditions any more than we covet the Hereros or Hawaiian natives to a morbid degree. Generally speaking, an intelligent and well-adjusted modern man does not place his paradise in the Prairie or in the heart of some bronzed Highland clan, although envying the great and simple assets that such plain conditions imply. He has caught a glimpse of something more subtle and more

satisfying. He really at last has a vision of his own; it plunges him back to more refreshing energies and oblivions than the noisy and snarling claptrap of the tribe and clan. "The artist" was formally identified with the savage or the school-boy to a disobliging extent, largely by thinkers impatient with the retrograde gushings and heroics of a type of rhyming or picture-painting crétin, as conservative as a woman, that the thinker was perpetually meeting, full of noisy Kiplingesque protest, at the opening of every street marked out by his sage mind for draining and sanification (to be "saved" because of its "picturesque bits"); and through constantly detecting this absurd bechevelured figure daubing pretty colours, like a malicious and stupid urchin, on every idea that had been pronounced moribund, and that was destined for the dustbin. But clearly this individual, this masquerader, this bag of schoolboy conceits, this old-clo merchant, loaded with rusty broadswords, Spanish knives, sombreros, oaths, the arch-priest of the romantic Bottle, was not an artist-type. Gauguin was not an artist-type. He was a savage type addicted to painting. He was in reality very like his sunny friends in the Marquesas Islands. He was in as limited a way a savage as an American negro is typic, or a Jew over-raced and over-sexed.° These are savages that go in for art for motives of vanity or disguised sex, in fact the individuals on whom the "sensational" theorists build their generalisations about the artist. Gauguin appears like a vulgar tripper by the side of Cézanne.

The music of Carmen, the Prince Igor° ballet, all the "savage stuff" that always gets the audience, is where the artist must be supposed, logically, to have his home. The truth is that in the trek of the imagination, of however feeble powers, from any man's Present outwards towards anything, the first region struck is the Savage time, clash of cymbals, howl of clansmen,

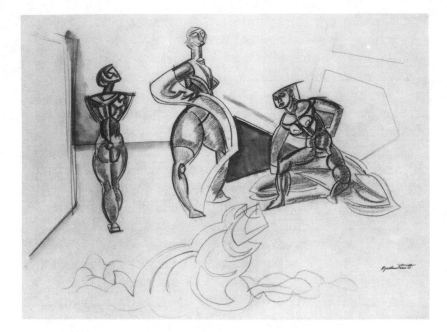

voluptuous belly-dance, Caucasian cartridge-pockets, castanettes, vendettas and corybantics. That is about as far as a respectable Public-school fancy takes you. It is like a scene from the more boring of the Russian ballets or a Victory Ball. And there *all* the "Chelsea artists" are to be found, every form of artist, far too many artists, in fact, and far too few "sauvages purs." But the sometimes festive philosopher is a bit of an "artist" of that sort himself. And it has been from such regions and hobnobbings that he has borne away his very firm convictions on the nature of "artists," and their abode in time. It is only since a variety of more adventurous men have pushed out beyond this sententious belt of savage life into lonelier regions, that a new type of "artist" has been met with, far rarer and far more venturesome, who has disposed already of much of the prestige of the dense herds of a manifestly different and falsely labelled species.

THE PHYSIOGNOMY OF OUR TIME

LIFE, SIMPLY, HOWEVER VIVID and tangible, is too material to be anything but a mechanism, and the seagull is not far removed from the hydroplane. Whether a stone flies and copulates, or remains respectably in its place, half hiding the violet from the eye,° is little matter. It is just as remarkable to be so hard and big as to be so busy and passionate; though owing to our busyness and passion we have a shoppy interest in the hurrying insect that we do not display for the stone. Life has begun, as language, for instance, begins, with a crowding and redundance that must be ordered and curtailed if the powerfullest instincts of life, even, are to triumph. Where everything is mutually destructive, and where immense multitudes of activities and modes of life have to be scrapped and excised, it is important not to linger in ecstasy over *everything*, simply because it *is*; or to sentimentalise about Life where creation is still possible and urgent; where much life, although pretty, powerful or bewitching, interferes with and opposes the life of something still more bewitching and strong.

The genius of the executant in art, the curiosity of the amateur, imply in their indiscriminate tasting and the promiscuity of their talent, an equal perfection in everything that succeeds in living, happens to move as swiftly, or far more swiftly, for its size, than the swiftest motor-car; or to fly as infallibly as the most perfected

73

plane we can imagine. And Marinetti (with his Caruso tenor-instincts of inflation, and mellifluous self-aggrandisement and tiptoe tirade), was, in his rant about *speed*, in the same position.° He might, ten thousand years before our wonderful time, have ranted about the lizard or the dragon-fly, with a deeper wonder at the necessities and triumphs their powers of displacement implied.

An act of creation in art may be as far removed from the life of the fashionable chattering animal as the amoeba from the monkey. Truth is as strange a bird as ever flew in a Chinese forest. What shall we do with it? Does it require a drab and fickle world to shine in? Can it thrive in anything but a rich and abundant setting? Shall it be allowed to become extinct, made war on by some ill-favoured reptile? Should it be caught and sent to the Zoo and fed by horrible Cockney brats on bastard buns? It is in any case difficult to admit the claims of the stuffed birds we have occasion to mention to peck at and refill themselves on the carcase of this more splendid creature.

We know that all our efforts indicate a desire to perfect and continue to create; to order, regulate, disinfect and stabilise our life. What I am proposing is activity, more deliberate and more intense, on the material we know and on our present very fallible stock. But that stock must be developed, not in the sense of the prize bullock, not simply fattened, elated, and made sleek with ideas proper to a ruminant species: but made the soul of things in this universe; until as a bird a man would be a first-rate growth, and even as a bullock, be stalled in a Palace. Let us substitute ourselves everywhere for the animal world; replace the tiger and the cormorant with some invention of our mind, so that we can intimately control this new Creation. The danger, as it would appear at present, and in our first

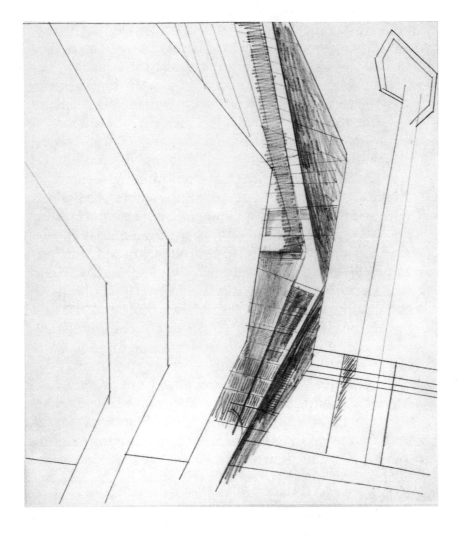

flight of substitution and remounting, is evidently that
we should become overpowered by our creation, and
become as mechanical as a tremendous insect world,
all our awakened reason entirely disappeared. Im-
mediately we can put a great deal behind us.

When I put forward my opinion that the aspect of life,
and the forms that surrounds us, *might*, perchance—
without too great sacrifice on the part of the painter,
without too great a disturbance for our dear conser-
vatisms and delicate obstructionisms—be modified, I
start fom Buddha rather than from Lipton, Maximilian
Harden or Madame Tussaud.° But I start from Buddha
with so much of the Fashion and spirit of our time as
he would have developed living in our midst to-day;
familiar with and delighting in the pleasant inventions
and local colour of our age; drinking Buchanan's Scotch
whisky with relish, smoking Three Nuns; familiar with
the smell of Harris tweeds, Euthymol, and the hot
pestiferous Tube wind.° I do not recommend any
abstraction of our mental structure, or more definite
unclothing than to strip till we come to the energetic
lines required.° So we have visualised a respectable and
legendary figure, appreciating Dunhill or Dubec tobac-
co, with no aversion to seeing Mae Marsh, or paying
homage to that uncanny piece of meat flinging itself in-
dignantly about nightly under the hungry nose of the
Monster of Mirth, the sturdy and priceless ape, George
Robey.°

Supposing that we destroyed every vestige of animal
and insect life on this planet, and substituted machines
of our invention, under immediate human control, for
this mass of mechanisms that we had wiped out, what
would be the guiding principle of these new masses?
The same as at present, the wild animal and insect
forms? Would we domesticate the universe, and make
it an immense hive working for our will, scavenging,

honey-making, fetching and carrying for man; or what? It is not a bird-like act for a man to set himself coldly to solve the riddle of the bird and understand it; as it is human to humanise it. So we do not wish to become a vulture or a swallow. We want to enjoy our consciousness, but to enjoy it in all forms of life, and use all modes and processes for our satisfaction. Having said *all* forms, we get back once more to the indiscriminate, mechanical and unprogressive world that we first considered. Only now we have substituted, in fancy, an approximate human invention for every form of animate life. It is evidently not this hungry, frigid and devouring existence of the scorpion, the wild cat or the eagle that we are disposed to perpetuate. Every living form is a miraculous mechanism, however, and every sanguinary, vicious or twisted need produces in Nature's workshop a series of mechanical arrangements extremely suggestive and interesting for the engineer, and almost invariably beautiful or interesting for the artist. The Marinetti rant around machinery is really, at bottom, adulation for the universe of beings, and especially the world of insects.

So the froth of a Futurist at the mere sight of a Vickers' biplane is the same as a foaming ode to the dragon-fly or the sea-gull; not for any super-mechanical attribute of the fly or the bird, but simply because one is a flying insect and the other a bird. And this all-inclusiveness of the direction of our thought is the result, primarily, of the all-inclusiveness of our knowledge.

The "gothic" stonemason, whose acquaintance with other forms of art than those he practised was no doubt relatively nil, was better off than we are. Similarly, the Modern Man, the abstraction that we all go to make, in absorbing the universe of beings unto himself and his immediate life as we have seen him, with his mechanical inventions, commencing to do, is equally

in the position of the dilettante. What is his synthesis
going to be? So far it has been endless imitation; he has
done nothing with his machinery but that. Will he ar-
rive where there is no power, enjoyment or organisa-
tion of which other living beings have been capable of
which he will not, in his turn, and by a huge mechanical
effort, possess the means? If he is amused enough with
his mind to give that carte blanche, his individual ex-
istence as an ape-like animal will grow less and less im-
portant. As already his body in no way indicates the
scope of his personal existence (as the bear's or the bar-
nacle's indicates theirs) it cannot any more in pictorial
art be used as his effective delimitation or sign. But that
is not to say that a piece of cheese or a coal scuttle can.
There is in the inorganic world an organism that is his:
and which, as much as his partially superseded body,
is in a position of mastery and higher significance over
the cheese and saucepan.°

FASHION

FASHION IS OF THE NATURE OF AN APERIENT. It is a patent
stimulus of use only to the constipated and the slug-
gish. It is the specific for the fifth rate, to correct the
stagnations that are perpetually gathering where life is
poor and inactive. The Victorian age produced a morass
of sugary comfort and amiableness, indulged men so
much that they became guys of sentiment. Against this
"sentimentality" people of course reacted. So the brutal
tap was turned on, and for fifty years it will be the thing
to be brutal, "unemotional." Against the absurdities that
this "inhuman" fashion does inevitably breed, you will
need some powerful corrective in due course. And so
your fashions go, a matter of the cold or the hot tap,
simply. The majority of people, the Intellectuals, the
Art World, are perpetually in some raw extreme. They
are "of their time" as a man is typically of his country,
truculently Prussian or delightfully French. So there are
some people who like cold in its place and hot in its
place, cold and hot out of their place, or the bath mixed
to some exact nuance. Actually how it works out is that
Cézanne, André Derain, Giotto,° the best stone carver
of the VII dynasty in Egypt, the Hottentot of talent, are
far more alike and nearer to each other in their reac-
tions, than any well-defined type man of the contiguous
ages of Queen Victoria and George V, with sixty years
only separating them. It is at no time unnecessary to

point out that what takes the glamour and starch out of the Chinese pigtail and the white hood of the Carmelite is when the pigtail proceeds from the scalp of Lao-Tse and the nun's coif surrounds the adorable features of Saint Theresa. East is East and West is West, and at a Macaroni meeting a post-Georgian swell would bristle with horror, and behave as the cat and the dog. But some men have the luck to possess a considerable release from these material attachments, and a powerful ear that enables them, like a woman in a restaurant, to overhear the conversations at all the neighbouring tables; to gaze at a number of revolutions at once, and catch the static and unvarying eye of Aristotle, a few revolutions away, or the later and more heterodox orb of Christ.

Part III
Paris

FRENCH REALISM

THE FRENCH TALENT IS NEITHER quite happy nor satisfactory in its "Classic," its "Romantic," or its "Scientific" manifestations. As a great "classic" or traditional artist you get Ingres. About him at present a considerable cult is in progress of springing up: whether it is a dealer's manoeuvre or a piece of French (and Allied) sentiment it is difficult to say. Probably it is both. But in the teeth of any fashion it should be easy to discern that Ingres, with all his dreary theatrical costume pieces of "classical" subjects is not as satisfactory an artist as Giotto, let us say, nor for that matter, as Raphael. His malicious and meticulous portraits give him a permanent and peculiar place. But it is not the place, nor quite the kind of place, that is being prepared for him. To admire Racine or Corneille, similarly, is an amusing game, but not a scientifically or emotionally exact proceeding.° If it is true, for instance, that Racine should be praised for his psychological insight, I prefer to find that without going into such a barren region to look for it. As a "Romantic," again, the Frenchman is a failure compared to the better equipped romantics of more romantic nations. Delacroix and Géricault are not as satisfactorily romantic as Turner; Victor Hugo's novels are not as good romances as Hoffmann's or Dostoievsky's.° Dostoievsky is nearer the real and permanent romance of life. Turner is a delightful dreamer, nearer

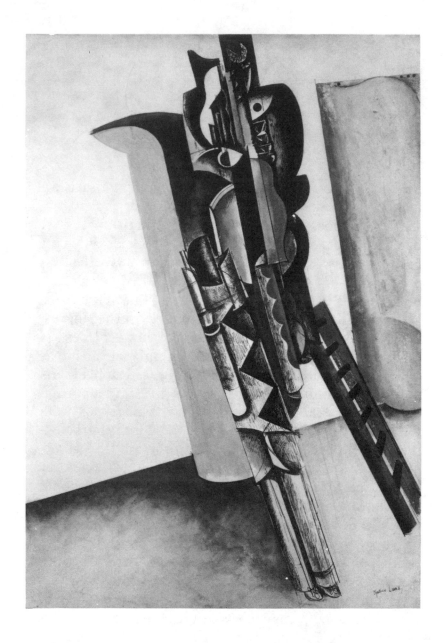

to the reality of romance than an equivalent Frenchman.

When he becomes scientific in a reaction against Romance or Traditionalism, as in the case of the Impressionists, or Pointillistes, in painting, the Frenchman becomes *too* scientific, in that likewise, to be quite real. The next thing you notice, having come to these conclusions, is that a variety of Frenchmen, Stendhal, Flaubert, Villon, Cézanne, Pascal, a big list — who form such a group, if stuck together, as to be more numerous than all the specific successes of another country put together — do not fit into the French national cadre. They are less local than the successes of other modern European countries. Dostoievsky, the most intoxicated of his worshippers must concede, has the blemish of being sometimes altogether too "Russian" to be bearable; too epileptic and heavy-souled. Turner had too much of the national prettiness of the "dreamy" Englishman.

French Realism means, if it has a meaning, what these best Frenchmen had: they were almost realler than anything in the modern world. They have made France the true leader-country. But it is not what people generally mean, in this land or elsewhere, when they talk about the "realism of the French." Reality is what you want, and not "realism." And to find that, you must watch for some happy blending of the vitality of "Romance," the coldness of "science," and the moderation and cohesion of a "classical" mind.

THE USES OF FASHION

HOW ARE WE TO REGARD the movement in painting that
has succeeded the Impressionist movement? As the
revenge of Raphael,° a pilgrimage to Poussin,° a
reawakening of austerity, a barbarous or a civilised
event? Creative Line once more asserted itself; the
rather formless naturalism of the Impressionist evolved
into what were once more synthetic and constructed
works. The tenets of catching the Moment on the hop,
of photographing that Moment of Nature with the eye,
and so forth, gave way before the onslaught of Inven-
tion, recuperated, and come out of its disgrace, dating
from the time of its supposed liaison with the Roman-
tics. Impressionism was really a period of decay itself,
or one of humdrum activity; a scavenging the ground
after the riots and too popular festivities of the
Romantics.

But then what you will base your views of these
movements on will really depend on what latitude you
give, in your mind, to human enterprise: how closely
you consider the possibilities of any short individual life:
and whether fanciful claims of Progress excite you or
not. Three or four human types—about as many as there
are large sub-divisions of the human race—Yellow,
White, Negritic—wrangle and wrestle about with each
other, rise, flourish and decay, then once more ascend.

The only flaw in this parallel is that the Black race

may die out, the Yellow predominate, or all races mingle
in a resultant grey-yellow mixture for some time. But
the types of mind are likelier stubbornly to persist and
maintain their struggle for mastery. There are different
kinds of Romantics, different sorts of Classics, and so
forth, but in any movement you may be sure that one
of these great warring sub-divisions is at the bottom of
the disturbance. It may be a composite movement. A
movement at once Scientific and Classic is possible for
instance. And all individuals are very mixed. Cézanne,
considering himself probably an Impressionist, as he
nominally was, only with, he would tell himself, a way
of his own of doing Impressionism, has turned out to
be something like a pure Classic. Derain, one of the two
or three most conspicuous figures in French painting
to-day, is almost a pure Romantic, in feeling, and capable
of every sentimentality. This is natural in a man for so
long a disciple of Gauguin, and the pasticheur of
Rousseau the douanier, as we find him in his ballet, "La
Boutique Fantasque."° Picasso has dealt, in earlier
periods of his work, in every sentimental and roman-
tic flavour. Most men with energy and illusion enough
in them to do anything have something of the complete,
composite character that I have in the preceding sec-
tion attributed to the chosen, most universal
Frenchman.

But a perfectly balanced, divinely composite *move-
ment* is an impossibility. Anything so intelligent or so
good as that is out of the question. For in the first place
that class is such a small one that the rare existence
of such individuals is quite independent of movements.
And, in the second place, were there numbers of such
men co-existing their aggregate of work would not be
a movement. It would be the reverse of that. Any move-
ment of such an obvious sort as we are considering

would bring them away from their centre. And for that they are disinclined.

So any movement is largely either a Romantic invasion or reaction: a Classical or a Scientific one. It usually will have the character of these limiting sub-divisions. It is the swing of the pendulum from side to side: it is the superficial corrective and fashionable play of the general sea of men. So all men must wear black in one generation, green in the next, then white, then black again: for that uniformity is a law of regulated life that cannot be contradicted. Fashion is the sort of useful substitute for conviction. At present it is the substitute for religion.

So you get the cry against tradition, the cry against emotion, or against superstition, or against science. Men's consciousness can only grasp one of these ideas at a time: they can only do any useful work under the spell of Fashion; that is, the one limited conformity prescribed for their generation.

The work of any artist living under this spell of fashion, unable to function without this stimulus, and to see beyond this convention, dates very quickly and is seldom remembered after his death, except through some prank of the erudite, or some accident of history. But this slavery to fashion is a different thing from the acceptance of the form, the data, and atmosphere of a time. Rowlandson could evidently have existed, from the testimony of his work, in no other time than the eighteenth century. He *used* the spirit, the form-content, the dress, the impressionability of his time with an uncanny completeness. But evidently had he been a dependent on fashion he could have done nothing of the sort. For he would have been far too afraid of what he handled, and far too obliged to it, to develop it in that bold and personal way.

I would apply this analysis of the general character

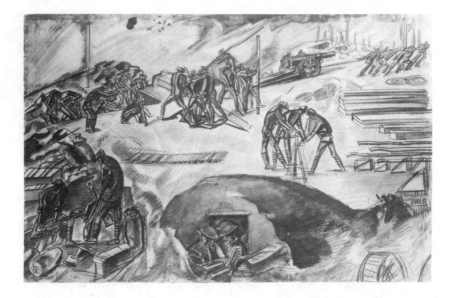

of movements to present events in the art of painting in the following way.

To a good painter, with some good work to do in this world, the only point of the new movement, or whatever you like to call it, was simply that it changed the outlook and pre-occupation of the living section of art from one mode to another. To look for anything more than the swing of the pendulum would be an absurdity. That *more* is supplied at the moment of every movement by the individual. And the painter who is at the same time an individual and the possessor of that "more," is not likely to try and find in a movement what he has in himself.° Still, the individual, although ideally independent of and superior to the flux and reflux, is beholden to conditions and to the society in which he finds himself for the possibility of the full development of his gifts. So the "movement" in art, like the attitude of the community to art, is not a thing to be superior about, though it is a thing you may be superior to. And really it is the same type of man who displays a sceptical aloofness and superiority as regards any activity directed to *improve* the conditions around us (*i.e.*, our own condition) who shows himself the most unimaginative and cringingly fashionable in respect of what he produces in the art he follows: the most assiduously up-to-date, the most afraid of opinion.

So this movement in painting really looked as though it were going to be the goods from the point of view of its uses for the best talents. Opportunities, through the successful even victorious progress with which the campaign began, seemed to be indicated for the full inventiveness of the human mind to get once more into painting, and its right to be there sure of a general recognition. This was at least a refreshing prospect, after the Impressionist years, during which this full inventiveness could show itself in painting only in some

ingenious disguise, or risk denunciation: or else pretend
that it had really come to look at the gas-meter, to grind
colours, or to scrub the floor. All this seemed for the
best: very much for the best! But naturally the ragtag
and bobtail of the "movement" would not look at it in
that light. For them it would be Le Mouvement, as who
should say the Social Revolution or La Carmagnole,
presided over by God Fashion, who is another form of
Dame Liberty.

So, has the worst happened? As far as Paris is con-
cerned, has the revolution turned into a joke, as it is
always liable to do in a Latin city? Or into some crafty
bourgeois reaction?

Let us recapitulate the possibilities: the reason that
would induce an individual painter to support this
movement, engage in it, and use it as a material op-
timistically. The creative line, structure, Imagination,
untrammelled by any pedantry of form or of naturalist
taboo, a more vigorous and permanent shaping of the
work undertaken: these were the inducements and the
prizes. The movement also developed a cult of experi-
ment which allowed of any combinations and inven-
tive phantasies. All the scientific notions as they came
along of any useful application could be used without
a foolish outcry. But this liberty and these opportunities
also begot a necessity for moderation or rather *concen-
tration* which would have been a vice in any age of
repression and academic tyranny. The painters have
been thankful for this disembarrassing of the ground for
them, and have been delighted at these splendid oppor-
tunities. They do not want to *lose* what has been won
by an infatuation for some effete mode that there is no
rhyme or reason to succumb to, apart from the
megalomania of an individual artist, or the commercial
promptings of some tortuous and sordid game. They do
not wish to be involved in the mere acrobatics of

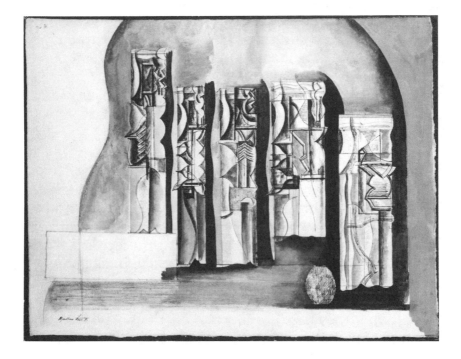

freedom. Freedom bristles with unexpected tyrannies. It would not have been easy for Cézanne, the laborious innovator and giver of this freedom, to do so; but any very able and at the same time resourceful artist could invent you a new mode *every week* without any difficulty; some new stylistic twist; some new adaptation of a scientific notion. This is not, however, what is needed. If he can do nothing *else* than that, he must be allowed to go his way, and his chief praise be a paean to his agility.

How we *need* and can *use* this freedom that we have is to invent a mode that will answer to the great mass sensibility of our time.° We want to construct hardily and profoundly without a hard-dying autocratic convention to dog us and interfere with our proceedings. But we want *one* mode, for there *is* only one mode for any one time, and all the other modes are for other times. Except as objects of technical interest and indirect stimulus, they have nothing to do with us. And it is not on the sensibility of the amateur, which is always corrupted, weak, and at the mercy of any wind that blows, that the painter should wish to build. It is on the block sensibility, the profoundest and most personal foundations of his particular time.

Fashion is not always the exact physiognomy of a time. And every physiognomy in any case is made to be changed.

What we really require are a few men who will *use* Fashion, the ruler of any age, the avenue through which alone that age can be approached to get something out of it, to build something in Fashion's atmosphere which can best flourish there, and which is the best thing that therein could flourish.

Picasso and the men associated with him seem to have taken their liberty at once too seriously and not seriously enough. They have taken Fashion, too, too

seriously on the one hand, and on the other they have not used it as they might, or done with it what they could. I do not see amongst them all, except possibly in Matisse, a man who is above Fashion, or one unimpressed by it.°

CÉZANNE

WHEN THIS VERY USEFUL PROCESS of corrective reaction occurred in the art centres of Europe twenty years ago, the Impressionists came in for the customary heavy reversal of opinion. But the root theories of the Impressionists remained in the consciousness of the new men, and completely as they might imagine they had discarded Impressionism, Naturalism, and the rest of that movement, Impressionist compunctions and fetishes could be found at every turn in the new painting. There was nothing wrong with this, for the Impressionists did much good work, and their experience was a useful one to inherit. This would no doubt not be apparent to the benighted body of the movement, but must have been to the leaders. And it was these leaders who cast round and went through their immediate heritage once more before finally discarding it. Here in turn the familiar faces of Degas, Manet, Renoir came up for inspection; also Cézanne. Cézanne came up rather crabbed and reluctant, a little aloof, and with something in his eye liable to awake suspicion. And sure enough suspicion awoke. In fact, what the journalist would describe as a "shrewd" suspicion grew up that this till then thought to be second-class artist, rather incompetent, though well-meaning old fellow, had something very useful and new in him; and was probably more a portion of the new sensibility, and possibly

of more intrinsic importance altogether, than any of his Impressionist contemporaries.

This suspicion grew into a furious conviction that a very great artist had been unearthed. He became the most fashionable art figure in the world. So much so that it is impossible to write three lines about painting to-day without mentioning his name. Matisse has not much to do with Cézanne. But the whole cubist movement comes out of him. Picasso is described by Lhote, the new apostle of David, as the interpreter of Cézanne.° More apples have been painted during the last fifteen years than have been eaten by painters in as many centuries. And all is for the best in the best of all possible worlds. But— Once more, it is a pity that this figure is so solitary (which means so much under present-day conditions of individual exaltation). The only advantage is that at least there you have a condition favourable to homogeneity and concentration of effort. This one, very narrow personality, enamoured of bulk, of simplicity, of constructive vision, sombre and plain as could be found, should be a boulder against a diffusion of the inroad of anything like a dilettante, indiscriminating sensibility. But possibly the weakness inherent in this first condition, of a lonely source, has left a loophole for the irresponsible, disintegrating passage of the second. I do not feel that Cézanne would have agreed to Ingres, much less to David. But he would be asked today to agree to Everything, five minutes devoted to each.°

THE GENERAL TENDENCY IN PARIS

IN PARIS TO-DAY THERE IS A MASS of "advanced" work being done, in the art of Painting and Design, which can roughly be classified as follows, not necessarily chronologically. For inevitably the degree in which a painting at present is "modern" is decided simply by its relative "abstractness." This is an unavoidable result of the startling innovation resulting from the progressive experimentation all over Europe during the last twenty years in painting. Whereas formerly it was a question whether you should paint a naked lady refined to some Greek type of the "beautiful" animal, or should choose her coarse, and give the Public a bit of the "real stuff," some lumpy Flemish frame squatting on the edge of a dingy soapy bath (approximating to the undraped Saskia,° to Degas or the facile Japanese realists); and whereas over periods of fifty years these opposing females were bandied about, and hurled at the head of the opposing faction; and it took half a century for the "Modern Art" of the time reluctantly to espouse one beauty, having laboriously divorced the last; to-day it has been found possible and expedient, within the trivial space of ten years, entirely to eliminate from the face of the earth the naked, clothed or other lady—every vestige or tatter even of a human being at all, from the horizon of the purest, of the latest, art. This is how the Public views this matter. And the Public, the ruffled,

101

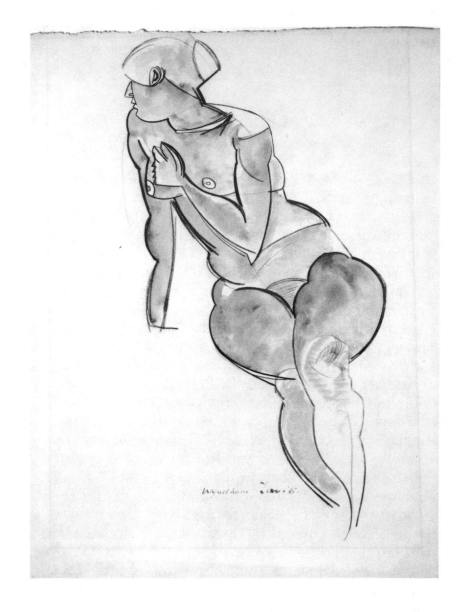

shaken, gasping but rather pleased, though not very helpful public, influences in his turn the Artist; and so back again.

Among the few hundred painters who form the façade of the temple of Fashion in Art, according to this rough and obvious classification, Kandinsky is the most advanced artist in Europe; Matisse, I suppose, of the same elect *avantgarde*, is the most leisurely, or the least furibundly outstripping. His "funniness" consists of distortion, or a simplicity akin to the facile images of French caricature, and a certain vivacity of tint, often, in his pictures.

To proceed with the classification of the modes of the new movement in Paris. Cézannism is by far the most widespread mode. As Cézanne may also be said to be at the bottom of "Cubism," he has really effected by the tremendous sincerity and certainty of his work a revolution in painting, and has made new eyes for a crowd of men. In the French show being held at Heal's Gallery in the Tottenham Court Road (August 7, 1919), fifty per cent. of the work is monotonously Cézannesque. In the best represented painter there, Modigliani, the heads of his sitters incline to this side or that because Mrs. Cézanne during the interminable sittings she must have undergone, drooped her head stoically and brutally in that way. She is, as it were, the leader of a Chorus of, from the standpoint of the theatre queue, very plain and even preposterous females. Similarly, that the hands meet and are crossed in the lap is a trick or habit in the search for the compact and simple that was Cézanne's occupation. Is there any lack of apples on tables? Do jugs abound? Are rigid napkins and tablecloths in evidence? Yes, they are everywhere in this exhibition, as in every other modern exhibition of the last eight years. Most of these things are a little more garishly coloured than Cézanne's still-lifes were, and side currents

arrive in the midst of the bed of apples and crockery, from Vuillard, or from Matisse or Van Gogh. But Cézanne is at the bottom of it, and will be for many a day.

The Futurists, and their French followers, have as the basis of their aesthetic the Impressionists generally. They are simply a rather abstruse and complex form of the 1880 French Impressionists. Their dogma is a brutal rhetorical Zolaism, on its creative side, saturated with the voyou respect and gush about Science, the romance of machinery engraven on their florid banner. On the technical side the Futurist paintings are again in their creative essence purely 1880 Impressionism, worked on by the same dogged logic, carried much further, and tinctured with Braquism and a score more odds and ends.°

MATISSE AND DERAIN

MATISSE AT HIS BEST IS CERTAINLY as good a painter as any working in Paris to-day. He possesses more vitality than Picasso; and he appears to have more stability — as a result possibly of that. I am not concerned in this pamphlet with recapitulating the phases of the modern movement, so much as analysing a late development of it, and only giving so much general matter again as is necessary to remind a non-specialist public of the rough points of the position up to date. Matisse has had far less influence than Picasso, and is in every way a different mentality. Derain, similarly, beyond influencing Picasso at a certain period, does not come within the scope of my immediate purpose. He is a great artist of impeccable taste. If I enlarge this treatise to book form, I shall devote sections to these artists.°

Of the names of artists working in Paris well known to us here, most are those of foreigners, not Frenchmen. Matisse, Picasso, Gris, Modigliani are Belgian,° Spanish, Italian. But outside of the large groups of artists working in Paris there are other European artists, some of equal note, and of equal importance in the history of this movement. Kandinsky among them, was, I believe, the first painter to make pictures of purely non-representative forms and colours.° And Kandinsky, with his Expressionism, is probably the most logical of the artists directing their attention to abstract experiment.

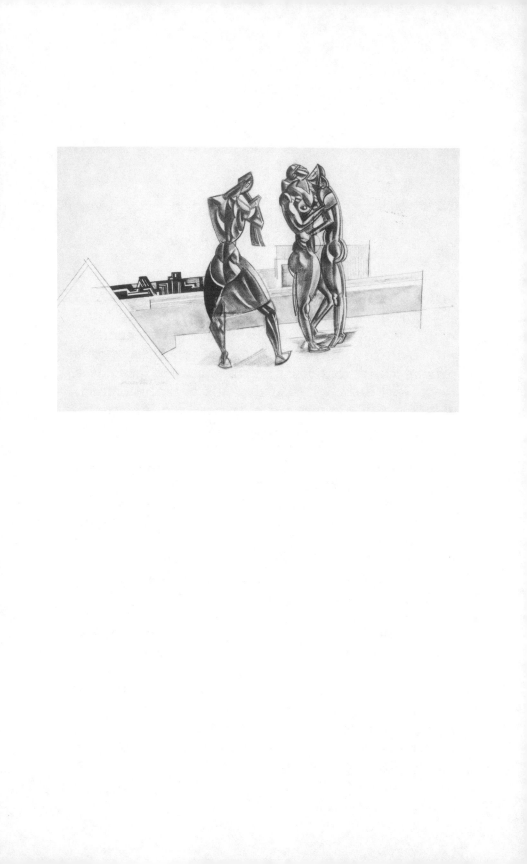

He is not obsessed by Natures Mortes; nor does one find in him the rather obvious obsession with common objects simply because they are common (which is a similarly limiting mode of the mind to the predilection for important and obviously significant objects). He differs from the Paris group in his interest for the disembodied world and the importance he attaches to this new avenue of research and inspiration. Actually his pictures possess too much of the vagueness and the effect of a drunken tracery that all spirit drawings have.

The painters working in England find no place in this pamphlet, but not because I do not esteem them. Nothing but a stupid parochial snobbism could make a half-dozen English names I can think of, seem any less weighty than any half-dozen French ones producible at this moment. As to the Jewish painters, they are evidently of the same race and talent everywhere. And there are at least as many here as in Paris.

First, this is not a review of painting in Europe. It is primarily an indication of what I consider is the only line that the painting of to-day can take if it is to justify itself, and not fizzle out in a fireworks of ingenious pseudo-scientific stunts, and ringing of stylistic changes on this mode and that. And the extra-studio preoccupations, the effort towards construction that I recommend, conflict with the spirit that appears to be guiding the cubist movement in Paris. The emotional impulse of the latest phases of that movement looks to me contradictory to any creative impulse in painting. And more clearly, it seems to preclude the development of any sensibility but that of an exasperated egotism. The eye becomes a little gluttonous instrument of enjoyment; or watches from the centre of its brain web for more flies and yet more flies. It would eventually become as mechanical and stupid as a spider, if it is not so already.

An effete and hysterical mechanism certainly

threatens every art. A sorrowful Eastern fatigue wed-
ded to a diabolical energy for materialistic reactions; a
showy and desiccated scepticism, wedded to a tearful
sentimentality as sweet and heavy as molasses. What
is to be done about that? But that is a problem for
another day.

Well, then, what I propose is that as much attention
might be given—it would end by being as concrete—to
the masses and entire form-content of life as has been
given by the Nature-morte school to the objects on a
table. If architecture and every related—as we say,
applied—art were affected and woken up, the same
thing would be accomplished on a big scale as is at pres-
ent attempted on a small scale. All the energies of art
would not be centred and congested in a few exasperated
spots of energy, it is true, or in a few individuals. But
the individual, even, would lose nothing by it, with
respect to the quality of his pictures. And a nobility and
cohesion would be attained that under present condi-
tions it is difficult to visualise. Most people grasping
at such a notion have stopped short at some fantastic
Utopian picture.

But to enable you to arrive at a fair estimate of my
conclusions, I must give you the analysis through which
I come by them in detail. And I cannot avoid some in-
vestigation of the record and evident moyens, a critical
survey, of Picasso.°

PICASSO

PABLO PICASSO IS ONE OF THE ABLEST living painters. It
would be impossible to display more ability. In addition
to this, he is extremely resourceful and inventive. The
back of his talent is too broad to suffer from even an
avalanche of criticism. It is the consciousness of this
that makes it more easy for me to state plainly his case
as I see it.°

This is, put pretty directly, what I feel about him.

With remarkable power he has refertilised many ex-
tinct modes, and authenticated interesting new and
specifically scientific notions. He has given El Greco
a new bit of life on the Catalan hills in his painting of
Spanish shepherds, oxherds and vagrants. He has revivi-
fied a great artist's line there, another's colour combina-
tions here, and has played the skilfulest variations. Since
every great creative painter must at the same time have
great executive ability—the more dexterity he can com-
mand the better—it is always difficult to decide where
this hand-training does or should leave off, and where
imaginative invention, apart from the delights and
triumphs of execution, may or does begin.

Briefly, Picasso's periods are as follows. His earliest
work contained a variety of experiments: women sit-
ting in cafés in reds; Daumier-like scenes, but more
fragile and rather definitely sentimentalised; then a
painting of a poor family standing by the side of a

languid and mournful bit of sea, their bones appearing through their clothes, their faces romantically haggard and delicate, and a general air of Maeterlinck or some modern German "poet-painter" all over it, has been widely reproduced. (Title: "Pauvres au bord de la Mer."°) Then came a period during which Derain's Gauguinism appealed to him. El Greco was a still more prolonged infatuation and source of study. Then Cézanne arrived in his painting. The portraits of Miss Stein and of Monsieur Sagot are of that time.

African carvings supplied the next step, in conjunction with the Marquesas Islands and André Derain. These solid and static models, African, Polynesian, Aix, drove out the Grecos, Maeterlincks and Puvises. Braque appears to have been the innovator in Cubism; and obviously in Braquism—the brown brand of mandoline, man's eye and bottle; lately, through Picasso's gayer agency, taking on brighter and purer colours. Futurism once more gave this Wandering Jew from not far from the Sierras a further marching order. Off his talent leapt into little gimcrack contrivances—*natures mortes*, in fact, come out of the canvas; little pieces of *nature-morte* sculpture, nature as the artist sees her, in fact; the bottle, mandoline and copy of *La Presse* reappearing out of art transfigured, after passing first through the artist's eye, spending a bit of time in the busy workshop of his brain, and so abiding for a year or so, into the flat world of the artist's canvas. After this series of hairbreadth adventures it is natural that this docile collection of objects should no longer remind the casual observer of any category of objects known to him.

In considering the future of painting, Picasso is the most useful figure on which to fix your attention. This is partly in his favour inasmuch as it recognises his activity; but it is the uncertain and mercurial quality of his genius, also, that makes him the symptomatic

object for your study and watchfulness. Everything comes out in him perfectly defined. Every influence in his sensitive intelligence burns up and shows itself to good advantage. There is nothing, as I have said, with regard to technical achievement, that he cannot do. He appears to me to have a genius similar to Charlie Chaplin's;° a gnome-like child. His clock stopped at fifteen summers (and he has seen more winters than Charles, although Charles is not averse to a Dickens scene of the Poor Orphan in the Snow), with all the shallowness of a very apt, facile, and fanciful child, and the miraculous skill you might expect in an exquisitely trained Bambino. These cases of arrested growth are very common in his race.° You merely have to consider what sort of a child you have to deal with, what moves him most; whether this mercurial vitality, so adaptive as to be flesh-creeping, is preferable to a vertical source of power, like the sour and volcanic old *crétin*, Cézanne. It is which manner of life you most prize, admire really. You have your critical flight; and I am ready for the moment to suspend you, glide you, spin you, plunge you, or stand you on your head, according to your fancy.

Now, if you are not used to critical flights, and you turn to me as one accustomed to banking, looping and splitarsing, and ask me what I advise, or, to put it another way, what is *my* fancy, I should answer as follows: "I consider Pablo Picasso as a very serious and beautiful performer in oil-paint, Italian chalk, Antoine ink, pastel, wax, cardboard, bread—anything, in fact. But he appears to me to be definitely in the category of executants, like Paganini, or to-day, Pachmann, or Moiseivitch;° where Cézanne is clearly a brother of Bach, and the Douanier was a cousin of Chardin."

That his more immediate and unwavering friends are dimly acquainted with this fact is proved by a statement I have just read, in the current (September 19) number

of the *Athenaeum*, by the French painter, M. André
Lhote:

> Cézanne embodies, through the romanticism with
> which he was impregnated, the avenging voice of Greece
> and Raphael. He constitutes the first recall to classical
> order. It was necessary, in order that the lesson he gave
> us might be understood, that an *interpreter* should ap-
> pear. This was Picasso.
>
> The young Spanish painter deciphered the multiple
> enigma, translated the mysterious language, spelt out,
> word by word, the stiff phrases. Picasso illuminates in
> the sunshine of his imagination the thousand facets of
> Cézanne's rich and restrained personality.°

What a performer on a pianoforte does in his concerts
is to give you a selection of the works of a variety of
musical composers. Now, apart from giving us very
complete interpretations of Cézanne, Daumier, El
Greco, Puvis, as Picasso has done, there are other ways,
and far more convincing ones, in which a painter can
betray the distinctively interpretative character of his
gift. What do all these phases and very serious
flutterings of Picasso's imply? To dash uneasily from
one seemingly personal mode to another may be a
diagnostic of the same highly sensitive but non-
centralized talent as you would think that a playing first
in the mode of El Greco and then of David probably
implied.° These are difficult things to decide since
painters *are*, through the nature of their art, at the same
time composers and executants. And you must usual-
ly get at this by consideration of, and sense for, the man's
work as a whole.

What has happened in this volatile and many-phased
career of Picasso's? Has he got bored with a thing the
moment it was within his grasp? And he certainly has
arrived on occasion at the possessive stage. If it is
boredom, associated with so much power, one is

compelled to wonder whether this power does not mechanically spring from a vitiated and tired source. He does not perhaps *believe* in what he has made. Is that it? And yet he is tirelessly compelled to go on achieving these images, immediately to be discarded.

But when we consider one by one, and with a detailed scrutiny, the best types of work representing his various periods, we must admit that he had certain reason in abandoning them. However good a pastiche of El Greco may be, it is not worth prolonging indefinitely this exercise. The same applies to his Daumieresque period. Splendid paintings as the Miss Stein and Monsieur Sagot undoubtedly are, they are still pure Cézanne.° And although many artists, among his dilettante admirers or his lesser brethren, would give their heads to produce such pure and almost first-hand Cézannes, once you *can* do this as easily as Picasso, it can hardly seem worth while to continue to do it. Very likely, at the present moment, his Ingres or David paintings will induce the same sensations of boredom in him (I can imagine David inducing *very* dismal feeling in an interpreter), and have a similar fate. All that remain to be considered are the less easily deciphered works of his more abstract periods. I think his effort of initiation and obstinacy in this brand of work showed a different temper to the other set of things that we have been considering. But they, again, are open to question. They reduce themselves to three principal phases. The first, or Cubist, phase, really a dogmatic and savage development of Cézanne's idiosyncrasy (example: "Dame jouant de la mandoline"°) is in a way the most satisfactory. But I am not convinced that Cézanne gains anything by what is a very interesting interpretation of his vision. But, on the other hand, the Lady with the Mandolin appears to me as interesting as a typical Cézanne portrait, and it is a powerful and inventive variation on Cézanne.

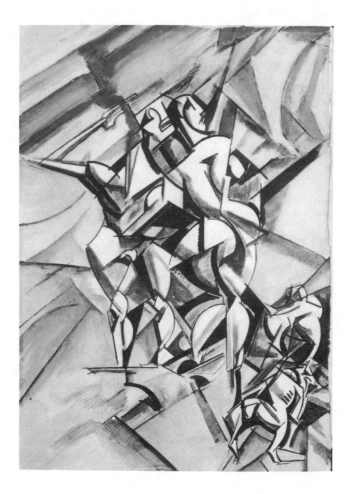

About the next step—fourth dimensional° preoccupa-
tions and new syntheses added to the earlier ones
("Dame assise") and the first Braque-like contrivances°
—you wonder if they are not more important as ex-
periments, and important because of their daring and
new nature, than as final works. But the whole character
of these things: the noble structural and ascetic qual-
ity, the feeling that he must have had, and that he im-
parted to them, that he was doing something at last
worth while, and in fitting relation to his superb
painter's gift—this makes them a more serious contribu-
tion to painting than anything else done by him. All the
admiration that you feel for the really great artist in
Picasso finds its most substantial footing in the extra-
ordinary series of works beginning with the paintings
of the time of the Miss Stein portrait, and finishing
somewhere in the beginning of his Braque period.

That, put as clearly and vividly as I am able, is my
account of Picasso up to, I suppose, about 1913 or 1912.
It must be remembered, however, that I have been
analysing this work according to the highest standards
that it is possible to apply to a painter. And in the light
of the subsequent work, with which I entirely disagree,
and for the purposes of combating the tendencies that
must inevitably result from its influence, I have
underlined those things in Picasso that would be liable
to result in the mechanical eclecticism that I describe
in the next section of this pamphlet (The Studio Game).
It has been a critical, and, in intention, destructive
analysis.°

Part IV
The Studio Game

FOREWORD TO PART IV

TWO THINGS HAVE CONSPIRED to exalt indifference in the painter to the life around him, and the forms that life takes, to a virtue.

For a specialised visual interest in the débris of your table, or the mandolin you have just bought, in copying the colours of the roofs seen from your garret-studio, is *not* the creative interest required for art. It is a parasitic interest. Your interest in the forms around you should be one liable to transfigure and constantly renew them: to use the grand masses of life, in fact, as the painter uses the objects on his table. He does not paint those objects as though he were photographing them. He arranges, simplifies, and changes them in his picture. So it should be with the larger form-content of general and public life.

Braque and Picasso have *changed*, indeed, the form-content before them, and with which they have dealt. Witness their little Nature-morte concoctions. But it has only been the débris of their rooms. Had they devoted as much of their attention to changing our common life, in every way not only the bigger, but the more vital and vivid game, they would have been finer and more useful figures: less precious, but not less good, artists.

Two things, then, have made this indifference displayed by most artists to their form-content come to

be regarded as a virtue. One is the general scepticism and discouragement which is a natural result of the conditions of our time. Intellectual exhaustion is the order of the day; and the work most likely to find acceptance with men in their present mood is that work that most vigorously and plainly announces the general bankruptcy and its own perdition. For the need of expression is, in a sense, never more acute than when people are imperturbably convinced of its futility. So the most living become the most life-like wax-works of the dead.

The painter stands in this year in Europe like an actor without a stage. Russia is a chaos; whether a good one or a bad one remains to be seen. Writing in Paris has fallen among the lowest talents. Painting is plunged into a tired orgy of colour-matching. A tessaract broods over Cézanne's apples. A fatuous and bouffonne mandolin has been brought from Spain; an illusive guitarist twangs formal airs amid the débris. Germany has been stunned and changed; for the better, pious hope says. But for the present art is not likely to revive there.

A great new vivacity seemed to spring up some ten years ago in the art of painting; and a number of the younger painters are embarked on an enterprise that involves considerable sacrifices and discomforts, an immense amount of application, and eager belief. This local effort has to contend with the scepticism of a shallow, tired and uncertain time; there is no great communal or personal force in the Western World of to-day, unless some new political hegemony supply it, for art to build on and to which to relate itself.

It is of importance, therefore, to a variety of painters, who have put their lives into this adventure, that it should not be, through the mistakes, the cupidity, or the scepticism of their leaders, or one mischance or another, brought to wreck.

This part of my pamphlet deals with a track at the

head of which a board advising avoidance should be placed; or, rather, against two tracks. For the Braque Nature-morte phase, and the David-Ingres phase in which painters in Paris are at present indulging is the same sort of thing, different as the results (a small abstract Nature-morte, and a large painting à la David) may appear.

OUR AESTHETES AND PLANK-ART

THERE ARE TWO ATTITUDES towards the material world that, one or other manifesting itself in him, an artist may very roughly be distributed on one side or the other of a creative pale. These attitudes can be approximated to the rôles of the sexes, and contain, no doubt, all the paradoxes of the great arbitrary sexual divisions of the race. An artist can Interpret or he can Create. There is for him, according to his temperament and kind, the alternative of the Receptive attitude or the Active and Changing one. One artist you see sitting ecstatic on his chair and gazing at a lily, at a portion of the wall-paper, stained and attractive, on the wall of his delightfully fortuitous room. He is enraptured by all the witty accidents that life, any life, brings to him. He sits before these phenomena enthralled, deliciously moved to an exquisite approval of the very happy juxtaposition of just that section of greenish wall-paper and his beautiful shabby brown trousers hanging from a nail beneath it. He notices in a gush of rapture that the white plate on the table intercepting the lower portion of the trousers cuts them in a white, determined, and well-meaning way. He purrs for some time (he is, Mr. Clive Bell° will tell you, in a state of sensitive agitation of an indescribable nature), and then he paints his picture.

He gushes about everything he sees. He is enraptured at the quality of the curious clumsy country print found

on the lodging-house wall; at the beauty of cheap china ornaments, a stupid chair, a staring, mean, pretentious little seaside house. When with anybody, he will titter or blink or faintly giggle when his attention is drawn to such a winning and lovely object. I am, you will perceive, drawing a picture of the English variety of art man. The most frequently used epithet will be "jolly" for the beautiful; and its pursuit will invariably be described as "fun." So we have before us, all said and done, a very playful fellow indeed, who quite enters into the spirit of this "amusing" life, and who is as true a "sportsman" as any red-coated squire; only for the pursuit of "jolly" little objects like stuffed birds, apples, or plates, areas of decayed wall-paper, and the form of game that he wishes rather smirkingly and naughtily to devour, he must be as cunning, languid, and untidy as his distinguished brother-sportsman is alert, hearty, and coloured like a letter-box. For stalking a stuffed bird you have, in the first place, to be a little bit dead yourself.

I have been portraying to the best of my ability the heir to the aesthete of the Wilde period: the sort of man who is in the direct *ligné* of Burne-Jones, Morris, and Kate Greenaway. And he is a very good example of how to receive rather than to give.

Now all the colour-matching, match-box-making, dressmaking, chair-painting game, carried on in a spirit of distinguished amateurish gallantry and refinement at the Omega workshops, before that institution became extinct,° was really *precisely the same thing*, only conducted with less vigour and intelligence, as the burst of abstract nature-mortism which has marked the last phase of the Cubist, or Braquish, movement in Paris. These assemblings of bits of newspaper, cloth, paint, buttons, tin, and other débris, stuck on to a plank, are more "amusing" than were the rather jaded and amateur tastefulness of the Omega workshops. But as regards the

Nature-mortists and Fitzroy tinkerers and tasters, one or other have recognized the affinity. Both equally are the opposite pole to the credence or intensity of creative art.

THE BAWDY CRITIC

UNDER A SERIES OF PROMPTINGS from Picasso, then, painting in Paris has been engineered into a certain position, that appears to me to bear far too striking a family likeness, in its spirit, to the sensibility of the English amateur to give one much hope for it. In the analysis of what I see as a deep weakness, and a scholarly, receptive and tasteful trend, rather than a creative one, I must put forward a little testimony, and devote a little space to what are otherwise thoroughly unimportant people. The important thing is obviously the painting in Paris, and not the type of English dilettante mind to which I compare it. But if I can make you see this real and striking community of temperament and intention, you will know better where you are when you find yourself in front of an arrangement of bits of newspaper, cloth, cheese parings, bird's feathers and tin. You might not otherwise come to the truth of this mystery at once. For the law that assembled these objects together will appear, and indeed is, more daring and abstruse than the more nerveless and more slovenly colour-matching and cushion-making to which I relate it. Again, it is really only what happens in a picture that is not organised to attract the objects that it depicts. Whether you stick a bit of wallpaper and a patch of trouser-leg side by side on a piece of wood, or use these objects in a picture painted on a piece of canvas, it is much the same. The

only thing that can be said of these particular experiments is that they demonstrate an exasperated interest in media and the shop side of painting, and a certain mental liveliness. But as regards them, there the life stops.

A desire to accept and enjoy: to accept what is already in the world, rather than to put something new there: to be in a state of permanent pâmoison° and rant about everything; the odder the thing, the *queerer* that you should find yourself fainting and ecstatic about it, the better—the *funnier*, you see? It is in the possession of this spirit, at bottom, that I am associating these two sets of people.

A composer of music does not, in his best or most specialised moments, fling himself into a luxurious ecstasy at a musical performance. The painter, similarly, does not derive from his own paintings, or other people's, "aesthetic ecstasies" or anything nice like that. He derives from the production of his own paintings, or should, a hundred times more pleasure than any bechevelured hysterical amateur is likely to find in front of *any* work of art. As a matter of fact, in most cases it is out of *himself*, not from the picture, or the art object, that the amateur gets his satisfaction. Hence the arcanely masturbatory tone in which some of them chant in the newspapers of their experiences. "Connoisseurs in pleasure—of whom I count myself one—know that nothing is more intensely delightful than the aesthetic thrill," etc., croons one.°

Unsatisfied sex accounts for much. You wonder if it is really a picture, after all, and not a woman or something else that is wanted, for the purposes of such a luxurious thrill. Is not most emotional interest in Music or Pictures, unaccompanied by the practice of the art enjoyed, sex? In fact, the painter or the musician are the only people for whom it is *not* sex. These

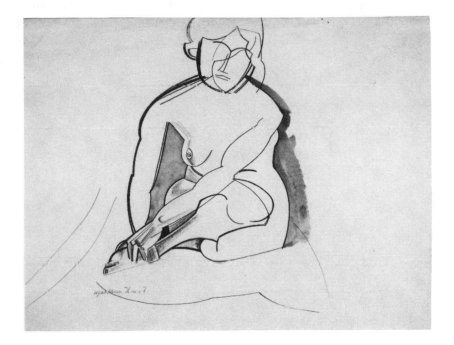

bawdy connoisseurs should really be kept out of the galleries. I can see a fine Renoir, some day, being mutilated: or an Augustus John being raped!

"WE FELL IN LOVE WITH THE BEAUTIFUL TILES IN THE SOUTH KENSINGTON MUSEUM REFRESHMENT ROOM"

IF WE INTEND THOROUGHLY TO PURSUE our Pablo into the deplorable corner into which his agile genius has led him, and others with him, we cannot do better than marry him, in our minds, for the moment, to the erudite form of Mr. Roger Fry. And if I devote a little space to the latter amiable gentleman, it is only to use him as a glow-worm by which we can the better examine Pablo's peculiar plight.

I will give you a passage from an article of Mr. Fry's which appeared in the *Athenaeum* of July 11 of this year.

> Objects of the most despised periods, or objects saturated for the ordinary man with the most vulgar and repulsive associations, may be grist to his (the artist's) mill. And so it happened that while the man of culture and the connoisseur firmly believed that art ended with the brothers Adam, Mr. Walter Sickert was already getting hold of stuffed birds and wax flowers just for his own queer game of tones and colours. And now the collector and the art-dealer will be knocking at Mr. Sickert's door to buy the treasures at twenty times the price the artist paid for them. Perhaps there are already younger artists who are getting excited about the tiles in the refreshment room at South Kensington, and when the social legend has gathered round the names of Sir Arthur Sullivan and Connie Gilchrist, will inspire in the cultured a deep admiration for the "aesthetic" period.°

Mr. Sickert you find embedded in the midst of this useful passage. He is a living and genuine painter; and is in that galère, therefore, you can take it, fortuitously. Notice, first, the stuffed birds got hold of by Mr. Fry's artist "for his queer game of tones and colours." Mr. Fry's artist's "queer game" is the same as Picasso's ingenious sport. Then we have a luxurious picture of "the collector and the art-dealer" knocking at the artist's door, and asking to buy his "treasures" (more luxury) — the stuffed birds that have been used in his "queer game" — for *Twenty Times the Price* paid for them. Next we have a little picture of the young students of the South Kensington School eating buns and milk in the Museum Refreshment Room, and oozing infatuated nothings about the tiles they find there; and going back with naughty, defiant minds to their academic lessons, their dear little heads full of the beautiful tiles they have seen while at lunch. "WE FELL IN LOVE with the beautiful tiles in the South Kensington Refreshment Room," to parody the famous advertisement. We think of the sugary couple on the walls of the Tube, that utter their melancholy joke and lure you to the saloons of the Hackney Furnishing Company; and we know that Mr. Fry's picture is as sentimental a one as that — the student "getting excited," the gush, the buns, and the tiles.

The last sentence of the passage I cite prophesies that "the cultured will at some future date conceive a deep admiration for the aesthetic period." After the tiles of South Kensington Museum, the faded delights of the aesthetic period! Mr. Fry chooses the aesthetic period as the subject of his prophetic vision because of a natural predilection that he no doubt feels for it, because he is a little bit in advance of his time in this respect. He already feels the thrill of such an admiration.

But you are to understand first that there is no mode of the human mind, no "period," no object of any sort

or description, that will not have its turn, and be en-
thused about either by the art-student, or the "cultured";
and secondly that this is very much as it should be, and
that this universal tasting and appreciation is all for the
best; quite the most suitable way of envisaging the art
of painting, sculpture and design.

It was no doubt, in the first place, a very naughty piece
of fun for this scholarly and fastidious art-critic, with
a name in Europe for his taste and knowledge of Italian
pictures, to find himself exclaiming in rapture over
some object as trivial as most of the objects he had up
till then dealt in had been rare. He naturally might find
this phenomenon absorbing. Theoretically he has no
predilections. All flowers are the same. But an especially
conscious plant on which he should chance to alight
would feel from his method of settling, the character
of his tâtonnements, that he had not alighted for the
purpose of extracting honey at all. Such a critic, at the
same time a dilettante, is not curious about the *object*
that his mind approaches, but is entirely engrossed with
himself and his own sensations. It is *amusing* to flit
from petal to petal; the grace with which you alight is
amusing; it is amusing that people should suppose that
you are engaged in such a dulcet business as gathering
honey; to bask in a slightly intoxicating pollen-
thickened atmosphere is delicious; but the fun is only
to *pretend* to be a bee.

The eclecticism, then, as regards modes and periods
of art, finds its natural development in an eclecticism
as regards objects. "A man's head is no more and no less
important than a pumpkin," from the article already
quoted. "Objects of the most despised periods may be
grist to his (the artist's) mill." Should art connoisseurs
and dilettantes all turn painters, the sort of art move-
ment they would like to find themselves in the midst
of (we are supposing them fashionably-minded, as many

are) would be such a giant amateurism and carnival of the eclectic sensibility as we are in for, if the dealers' riot in Paris succeeds, and if the votaries of Nature-mortism and the champions of the eclectic sensibility here, are to be believed.

We see exhibitions of French painting written about in the tone of an intellectual tourist, as though they constituted an entirely new thing in the way of pornographic side-shows, to which the English tripper is immediately led on his arrival in Paris. The "aesthetic thrill" obtained at these shows is described in an eager and salacious key, and with many a chuckle. The truth is that for the amateur turned critic, or the amateur painter, these modern painter's experiments still remain imbued, as they do for the public, with a great deal of naughtiness. The especially English philandering flapper-sensibility transpires in every sentence of their accounts of shows. There we have then our indigenous aesthete splayed out for our leisurely observation.

I will now give you a few lines of an interview with Picasso, which appeared in the *Weekly Dispatch*° of June 1 of this year:

> Picasso was enchanted with our metropolis (London). He waxed excited over our colourful motor-omnibuses.
> And Picasso had a thrill of joy on discovering a pavement artist. "This good man knelt down and drew in coloured chalks on the stone. I assure you, they are admirable."

The motor buses are the same as the tiles in the Refreshment Room. The pavement artist is the eternal Naif or Gifted Child. When will the Naif, the Pavement Artist and the Child resume their places, qua Child or Naif simply: the very good Naif, like the very good Child, as rare as anything else very good, alone remaining in our foregrounds?

And it is easy to see how Picasso, wonderful artist as he is, has encouraged this hope of a thoroughly detestable state of amateurish art — naughtiness, scepticism, and sham, setting in here and in Paris. Certainly, if you do not want to be turned into a tasting-machine, you will not have any truck with the studio-game into which the general movement in painting to-day has been sidetracked.

THE VENGEANCE OF RAPHAEL

DAVID IS THE ORDER OF THE DAY. David, the stiffest, the dreariest pseudo-classic, has been seized on (as a savage tribe might take one of their idols by the heels and drag him out), and has been told in frenzied and theatrical accents that he must Avenge himself! And being probably a rather peppery and bloody minded little French man, revenge himself he will, if he is not stopped! Or, rather, M. Lhote, his self-appointed executioner, will do the job for him. Picasso, alleged to be doing portraits in the manner of Ingres, is the cloaked and consenting, of course Spanish, figure in the background of this "classical" razzia. "Raphael shall be avenged!" shrieks M. Lhote. I have heard from people who have seen this artist in Paris in the last month or so that he is really very excited, and that the Madonna-like face of the Florentine master inspires him to very great fury: a fury of idolatrous love, a determination to make short work of those who have played ducks and drakes with their inheritance of Greek beauty.

The parrot-like echo of all this turmoil turns up punctually in our Press. I saw this week in a current art article the first tinkle of the eulogistic thunder that is shortly to burst, everything indicates, around the Parthenon Frieze in the British Museum. Nasir Pal's square semitic shoulders may get a pat or two in passing. But it will be in the Greek gallery where all the fun of the

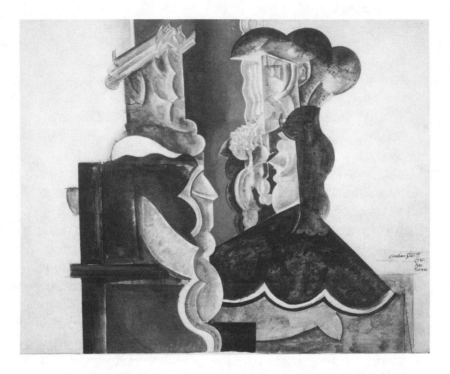

fair will rage. These draped idealities have already been described as *distorted*, to bring them into line!

Ingres, David, Raphael! Poussin and Claude! Easter Island carvings, El Greco, Byzantium! But there is a vast field yet to cover: the friezes from Nineveh, the heart of Sung, Koyetzu and Sotetzu, the Ajanta caves, Peru, Benin; and the Polar regions have their unhappy dolls, harpoon handles, and the Midnight Sun for some future ballet!

This is leaving out of count the tiles in the South Kensington refreshment room and the "aesthetic period," and a million other such varieties. What incredible distances the art-parasite travels!

Is Western Europe too uncertain of to-morrow, the collapse of religion too dislocating, Great Wars too untimely, for us to have an art that is any more than locally or individually constructive? I am convinced that the sooner the general European destiny of painting gets out of the hands of the dealers' ring in Paris the better for it. Also the hysterical second-rate Frenchman, with his morbid hankering after his mother-tradition, the eternal Graeco-Roman, should be discouraged.° And I think that Picasso could be indicted of more than a personal and excusable vacillation. And his personal limitations should be stated and understood, as Cézanne's, or any other individual man's should be, where they conflict with anything that is more living even than the individual.

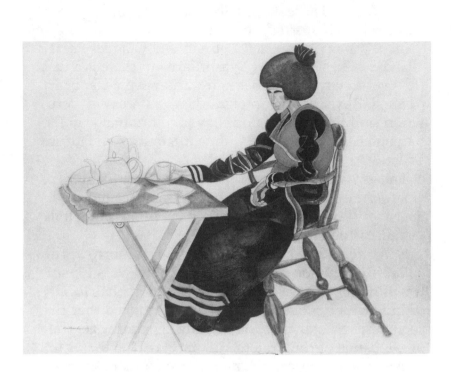

GENERAL NATURE AND
THE SPECIALISED SENSE

WHEN IT WAS NECESSARY in this country and elsewhere to undertake a rapid education of a Public of some sort, some exaggeration had to be indulged in. If a man was persuaded of the reality of his enthusiasms, the position had to be posed *too logically* for reality, or to be exact. Also everything in the innovation that contradicted the tenets of the prevalent and tired sensibility had to be thrown into a crude saillance.°

But to-day this necessity no longer exists.

Yet writers supporting, more or less, the great movement in painting going on everywhere in Europe, still repeat the lesson as it was given them. The statement, for instance, that a man's head is no more and no less important than a pumpkin indicates a considerable truth: it depends in what connection, only, that it is advanced and how applied. The ideal of the pure visual has obviously no preoccupation but formal and colour ones. But when you say that Cézanne, an heroic visual pure, in his portrait of the two men playing cards, was emotionally moved only by the form and colour, you are omitting a great sub-conscious travail of the emotion which fashioned along with the pure painter's sense; dyeing with a sombreness and rough vitality everything that he did. There is no painter's sense, admittedly, so "unbiological" that it can be independent

of this extra-sensual activity of the painter's nature. His disposition, his temper, his stubbornness, or his natural gaiety are all there in his specialised sense. Given the undoubted and fundamental rightness of this sense, it is an open question how far the emotional non-specialised activity of the mind should be stimulated and how explicit its participation should be in the work of a painter.

The important thing is that the individual should be born a painter. Once he is that, it appears to me that the latitude he may consider his is almost without limit. Such powerful specialised senses as he must have are not likely to be overridden by anything. He would laugh at you if you came along with your "head and pumpkin."

To sum up: On the subject of eclecticism, if there were no painters and therefore no art, the dilettante would have nothing to be eclectic about. Secondly, no good painter has ever been eclectic or very fickle in his manner of work.° And if the complexity and scepticism of his time drives an artist into the rôle of the dilettante, or interpretative performer only, that is unlucky for him. It is not in the interest of painters, but only of the stunt amateur, or the dealer, to keep silent on that point.°

APPENDICES

Afterword
Note on the Illustrations
Explanatory Notes
Table of Variants

AFTERWORD

THE CALIPH'S DESIGN WAS FIRST published by The Egoist in 1919, and marked Wyndham Lewis's resumption of his position as a leader of London's artistic avant garde after returning from war service in France. In the two issues of *Blast*,[1] Lewis had already shown himself to be one of the most intelligent and informed—and certainly the most incisive—critic of the new art movements, Cubism, Futurism and Expressionism. His criticism penetrated to the essential issues because he shared the revolutionary attitude that lay behind the pictorial innovations: the new art was a forerunner of a new world, and the task of painting was to bring to light the new possibilities of consciousness in the modern world.

Lewis returned from the First World War with his enthusiasm for a new creation undiminished. *The Caliph's Design* is a vivid expression of that enthusiasm, and celebrates the creative imagination's ability to evolve a visual environment that would "increase gusto and belief in . . . life" and make available to the mass of society that condition of mind which was already the artist's: "this state of mind of relish, of fullness and exultation."

Lewis argues for a new architecture imbued with this spirit: unornamented but shaped by the creative

[1] For this and subsequent notes to the Afterword, see page 161.

145

inventions of the most advanced painters. The truest artist invents as prolifically and profligately as nature's primeval forces; "the artist [is] older than the fish." Lewis contrasts this creative artistic activity with the more dilute predominating forms of contemporary experimentalism—the artist as amateur, as child, as dilettante, as pseudo-primitive. His mocking critique of neoclassicism, Picasso, Matisse and the School of Paris constitutes some of his wittiest and most brilliant writing, but its cutting edge is Lewis's conviction that the creative imagination is superior to atavism and inertia. His most scathing criticisms are reserved for the tasteful efforts of the Bloomsbury aesthetes. His writing conveys a sense of exhilaration and vitality matched by no other critic because he was himself a painter at the forefront of Modernist art, and it was as a painter committed to the purest revolutionary creation that he excoriated the half-heartedness of his contemporaries.

The Caliph's Design is of central importance to an understanding of Modernism in the arts, though few readers of the histories of European or English Modernism would be likely even to discover the pamphlet's existence. Its engagement in the debate about the future of the arts after the great period of revolutionary experiment before the First World War is so alive and intelligent that its arguments not only retain the power to provoke fresh thought about artists of that period, especially Picasso and the School of Paris, but have immediate relevance to the arts of today. In fact, like all great criticism, *The Caliph's Design* appears to give permanent expression to a vision of the nature of art, and has a lasting capacity to awaken wonder before the strangely discomforting power of the creative imagination:

The creation of a work of art is an act of the same description as the evolution of wings on the sides of a fish, the feathering of its fins; or the invention of a weapon within the body of a hymenopter to enable it to meet the terrible needs of its life. The ghostly and burning growths, the walking twigs and flying stones, the two anguished notes that are the voice of a being, the vapid twitter, the bellows of age-long insurrection and discontent, the complacent screech, all may be considered as types of art, all equally perfect, but not all equally desirable.

—"not all equally desirable"; as often with Lewis we are startled and disoriented by a sudden change in the direction of the argument, here complicating what at first seems a uniquely wholehearted and forceful commitment to Darwinian primitivism. Lewis's writing is energetic and incomparably vivid—alive with violent, comic and contemptuous imagery—yet delineates subtle arguments and acknowledges issues that more respectable thinkers ignore. As Ezra Pound wrote in 1937 of Lewis the Vorticist:

The whole public and even those of us who then knew him best, have been so befuddled with the concept of Lewis as EXPLOSIVE that scarcely anyone has had the sense or the patience to look calmly at his perfectly equanimous suave and equipoised observations. . . . The difference between a gun and a tree is a difference of tempo. The tree explodes every spring.[2]

The Caliph's Design is also of central importance to an understanding of Lewis's own work as a whole. Despite the negative emphasis of many of its reflections on modern art, it is one of Lewis's most unequivocally positive statements of the importance of creative art in the invention of new modes of consciousness. It is thus an essential point of reference from which many of

Lewis's other books, and paintings, can be understood.
The Wyndham Lewis of the cultural polemics of the
twenties can only be mistaken for an artistic reactionary
(as he frequently is) if the presence within those
polemics of the radicalism of *The Caliph's Design* is ig-
nored; as in the following, from *Time and Western Man*,
for example: "Life as interpreted by the poet or
philosopher is the objective of Revolution, they are the
substance of its Promised Land."[3]

The Caliph's Design is a key, also, to Lewis's later
satire, and he returned to its central vision again and
again both to nourish his conception of what the im-
agination might make of the world, and to articulate
by contrast a savage relish in the apparent impotence
of art to affect the actual world's banality.

There are many reasons why this superb pamphlet
has been virtually expunged from history. One is that
Lewis's close alignment with international Modernism
was temporary. One of the major presuppositions of
Modernism, emphasized especially by the Futurists, was
that the artist's work should directly change life: art
becomes a branch of politics (or *vice versa*—the crux
of the Marxist quarrel with Modernism). The avant
garde is not simply a clique of bohemians but an advance
guard of militants, pioneering not just the art, but also
the life of the future. Such a direct fusion of life and
art is explicitly rejected by Wyndham Lewis in *Blast*,
and the Futurist desire to change the world directly is
disclaimed:

> We do not want to change the appearance of the world,
> because we do not depend on the appearance of the world
> for our art.[4]

Though Lewis's Vorticism aimed at changing art and
pioneering new forms of consciousness, it had no wish
to become involved in directly "improving" life, for that

is not the painter's business. Lewis had good theoretical reasons for insisting on this. A painter can be free in his work to synthesize in visual form his varied perceptions of his society in a way as purely speculative as the philosopher's way with ideas. But working in the medium of "life," all the tragic possibilities of speculative action and the constraints of actual social organizations mean that his work's "destiny is different": "Once an artist gets caught in that machinery, he is soon cut in half—literally so."[5]

Before the war, Lewis had maintained a position of aloof detachment from society in general, cursing alike the proletariat, the bourgeoisie and the aristocracy. But his experience of life in the trenches, while it hardly increased his respect for man in general, induced some fellow-feeling for the ordinary men who were slaughtered in thousands. Lewis himself only escaped by good luck. Perhaps it was this sympathy that led Lewis in 1919 to modify his earlier position and, in *The Caliph's Design*, actively propose a practical application of the formal inventions he and others pioneered in their geometrical paintings. This brought Lewis closer in his arguments to the Futurist desire to change life. In 1919 he wishes to change the appearance of the world for the benefit of the common man in order to increase his zest for life. Perhaps the common man will still ultimately be led, like a bullock, to the slaughter by his rulers, but he would at least until then "be stalled in a Palace."

So for a brief period Lewis seems fully at one with the most advanced innovators and theorists of Modernism (he was not alone in his doubts about the direction Picasso's art was taking). His emphasis on architecture as the field of innovation is also thoroughly in tune with a central impulse of Modernism at this time. Visionary plans to create entirely new cities and new social organizations within them were typical projects of

Modernism, from Sant'Elia's designs for a *Città Nuova*
(1913–14), to Tony Garnier's *Une Cité Industrielle*
(published 1918), Bruno Taut's *Die Stadtkröne* (1919),
and Le Corbusier's numerous schemes for rebuilding
Paris, such as his project for *Une Ville Contemporaine*
(1921–22).

Only in England did this visionary enthusiasm have
virtually no practical results. When Lewis decided in
the early twenties not to move to Paris, he virtually
ensured his isolation from the mainstream of Modern-
ism, especially in the field of architecture and design.
For in the development of the International Style
England is conspicuously absent from the histories, its
contribution being limited to the earlier development
of the "Garden City" and the "English House" in the work
of Webb, Voysey and Lethaby. Yet the work of Wynd-
ham Lewis represents, as it were, the ghost of an English
contribution, scarcely mentioned by the belated British
pioneers of "Unit One" and *Circle,* who discovered
Modernism in the thirties.

Lewis's choice of an Arabian Nights setting for his
parable of *The Caliph's Design* is surely a tacit
acknowledgment that Modernism will always seem an
exotic import in Britain; though at the same time the
setting serves to remind that a taste for the exotic does
exist amidst all the Podsnappery. Certainly Lewis knew
that Britain was uniquely unhospitable to artistic in-
novation. Even the educated élite would only accept
"abstract art" and "modern architecture" twenty years
after their invention. And if *The Caliph's Design* marks
the aborted beginning of international Modernism in
London, with its powerful Caliph demolishing and
rebuilding at will, history has provided a curiously sym-
metrical ending to the story. In 1962 a modern
"caliph"—a property developer named Peter Palumbo—
commissioned Mies van der Rohe (a high priest of the

International Style) to design a twenty-storey tower block and a square in which to site it. Commercial buildings in the heart of the City (in front of the Mansion House—the symbolic centre of the financial district) would be bought up and demolished. Within thirty years (rather longer than the Caliph of Baghdad's single month) a new square would transfigure the heart of that cultivated city. Planning authorities gave preliminary approval, the buying began, and Mies brought his designs to their finished state a few weeks before his death in 1969. In 1982 Mr Palumbo was at last ready to proceed, so he applied for formal planning permission from the City of London Corporation. After seventeen minutes' discussion they decided to refuse permission. A public enquiry costing a million pounds was held, and in the spring of 1985 it upheld the planning authority's decision; the picturesque old Nineteenth Century commercial buildings on the site should be preserved. This recommendation went to the Secretary of State for the Environment, and thence, it is said, to the Prime Minister herself, but with no change in the result; Modernist ambition for London has been given its symbolic *coup de grâce*.

Despite the ironic symmetry of this contemporary attempt to implement something like *The Caliph's Design*, Wyndham Lewis's Modernism, as I hope will become clear, was not quite that of the International Style which reached its high point in the work of Mies. The similarities between Lewis's Modernist ambitions and those of the European avant garde of 1919 need to be stressed, but differences should also be noticed.

The immediate post-war period saw a co-ordination of various currents of Modernism in art and design. The lines of communication between France, Germany, Russia and Holland have been frequently sketched in histories of modern architecture. Some of the main

centres of activity were Léonce Rosenberg's Paris gallery *L'Effort Moderne* and the magazine *L'Esprit Nouveau*, with which Le Corbusier was associated; in Berlin the gallery and magazine of Herwarth Walden, both called *Der Sturm*, which had connections with the Bauhaus; the ideas and style of Russian Suprematism were brought to Europe particularly by El Lissitzky; from Holland the much-travelled Theo Van Doesburg provided an important forum in his magazine *de Stijl*. By 1925, with the construction of the Deutscher Werkbund's exhibition at Wiessenhof to the plans of Mies van der Rohe, the establishment of a truly international style of modern design had been visibly achieved.[6]

The record of contacts and influences traces the translation of the visual revolution from the easel pictures of the pre-war geometrical abstractionists into the real world of three-dimensional design. Accompanying this is the development of a set of largely utopian justificatory theories about society, technology and art. As a pioneer of geometric abstraction in painting who proposed that those paintings should provide the visual vocabulary of a new architecture, Lewis should thus be established as an important British representative of this movement towards an International Style. His was not a provincial, or even an individualistic, demand for a style local to Britain, but for a single style strong enough to sustain the creative energies of all Europe. At the time of writing *The Caliph's Design*, he does not appear to have been in touch with his European contemporaries; hence perhaps his concentration on attacking the School of Paris and the Bloomsbury group for their failure of creative imagination. He does not draw upon the growing avant garde of Europe to support his revolutionary proposals; instead he refers to W. R. Lethaby's important contribution to a series of popular educational books (the Home University Library), *Architecture*.

But by 1921 Lewis was in touch with Herwarth Walden (whom he visited in Berlin) and promised to send him pictures for a show to be held in Paris; in 1922 he was planning a show at Léonce Rosenberg's *L'Effort Moderne* gallery; both *L'Esprit Nouveau* and *de Stijl* were advertised in Lewis's 1922 *Tyro* (no. 2); he was in correspondence with Van Doesburg, who printed a passage from Lewis's 1922 *Tyro* "Essay on the Objective of Plastic Art in Our Time" in the Blue issue of his Dadaist magazine *Mécano* (1922).[7] Lewis's contacts with Russia do not appear to have been so direct, but copies of *Blast* may have found their way there, for Lewis's Vorticist *Portrait of an Englishwoman* was reproduced in Mayakovsky's Futurist miscellany *The Archer* in early 1915, prefiguring similar geometric abstractions by Kasemir Malevich; El Lissitzky later acknowledged the influence of *Blast*'s typography on his own work.

Yet Lewis never made the effort to establish himself as a Modernist artist with international standing, and during the twenties he worked far more on his writing than he did on his painting. As for the *The Caliph's Design*'s ambitious proposals: realizing the political complexity of the real world (abridged in the invention of an all-powerful Caliph), Lewis made political theory the subject of his next book, *The Art of Being Ruled* (1926). The reasons for this change of direction at this stage of Lewis's life are not altogether clear. Perhaps he perceived in his own work elements that appeared to contradict the Modernist movement he was beginning to be associated with, and he wished to reflect upon, and rebuild his career around, these contradictory elements. For these deeper differences are already present in Lewis's practice as a painter and in the theorising of *The Caliph's Design*. An artist more single-mindedly dedicated to the medium of painting, working in a more conducive atmosphere than England and

not diverted from his course by his own overwhelming talent in the literary medium, would have worked through these contradictions more thoroughly in his painting than Lewis did; but perhaps it was the double-barrelled nature of Lewis's talent that created the contradictions and rendered them acute in the first place.

Lewis's creative interest in architecture contradicted one of the fundamental principles of his practice as a visual artist: his avoidance of the third dimension. The third dimension was fatal to his art, paradoxically, because of the strong plastic qualities of his drawing. (Jacob Epstein remarked to Ezra Pound that Lewis's pictures possessed the qualities of sculpture.) Lewis knew that his paintings and drawings risked becoming banal if translated into three-dimensional material objects.[8] This fear underlies the criticism of Picasso's 1912 constructions quoted above: "The moment an image steps from the convention of the canvas into life, its destiny is different." The artist working in the dimension of life gets "cut in half," Lewis had warned; so his artist-caliph gives to an engineer and an architect the responsibility of translating the image on the canvas into three-dimensional life. If they fail to accomplish it, they too will be cut in half: "your heads will fall as soon as I have been informed of your failure. . . ." The Caliph, on the other hand, will be free to continue drafting his utopian designs unhindered; despite wishing to see the real world changed, Wyndham Lewis in 1919, as in 1914, wants to operate in a field of purely speculative imagination: the convention of the canvas.

Here emerges a crucial difference between the Modernism projected by Lewis's pamphlet and the actual Modernism that I have suggested met its Waterloo at the Mansion House. Put crudely, the first problem facing an engineer in inventing the shapes and conditions that would make it possible to realize Lewis's

Vorticist designs as architecture is that the vertiginous instability of their various elements suggests no realizable three-dimensional object at all. How could a real structure be made to look like one of Lewis's compositions (*Planners*, for instance, or even *New York*[9])? And if, by some feat of creative engineering it could, how could the structure be used as a building? Contrast the placid reflective planes of a Mies house design, its pure geometries virtually indistinguishable from those of a de Stijl abstraction. At least an engineer called in by a de Stijl Caliph would know what his building was supposed to look like; the walls would be vertical, corners square and floors and ceilings horizontal, for example.

Lewis's Vorticist abstractions work by being fundamentally fictional: their destiny is to remain within the conventions of our interpretation of two dimensions, however self-contradictory they are in their deployment of those conventions. The self-contradiction is essential; Lewis's abstractions contain a multiplicity of overlapping perceptual possibilities held in a tension which is sometimes violent, sometimes exhilarating. The overlapping possibilities correspond to Lewis's perception of life in the modern city:

> . . . the frontiers interpenetrate, individual demarcations are confused and interests dispersed. . . .
>
> We all today (possibly with a coldness reminiscent of the insect-world) are in each other's vitals—overlap, intersect, and are Siamese to any extent.[10]

Perceptual multiplicity means that no one reading of a Vorticist picture takes precedence but exists alongside other incompatible but overlapping perceptions. Thus the pictures are not "pure form" and the Vorticist will not complain if a spectator wishes to interpret a crowd of squarish shapes in his picture as a window.

The main perceptual references to the world appear to be "Skyscraper" architecture and street scenes, machine forms and the human figure. The perceptual paradigms through which the image is formed and constantly redistributed are the "plan," architectural or military, as in the battle-plan where forces and their strengths are represented by conventional blocks and lines; engineers' drawings of machines; and the conventional perspective drawing in which converging lines represent depth behind the picture plane or as in Japanese prints where parallel diagonals represent a third dimension. In the terminology of Charles Jencks,[11] these pictures are "multivalent" (as is the richest experience in the modern city) in that they are open to multiple explorations by the imagination, and resist being assimilated to a single ("univalent") reading; "For ... the single object, and the isolated, is, you will admit, an absurdity."[12] So these abstractions are not directly transferrable to architecture, though an architecture based on their characteristic forms might be possible. To be true to the two-dimensional multivalency of the pictures, the architecture would need its own form of three-dimensional multivalency, preserving the pictures' suggestion of multiplying life's possibilities instead of imposing on the user of the building a univalent experience. A Lewisian modern architecture, then, like the whole programme of inventive modernization he proposes in *The Caliph's Design*, would have as its aim to increase gusto and belief in life, to use our inventions to enjoy all the possibilities of organic life experienced by other species without being reduced to animal or mechanical functionalism (see Part II, section 2, "The Physiognomy of Our Time.").

While equally enthusiastic about the replacement of nature by a technological environment, the ideology of the International Style has "functionalism" as one of

the main parts of its programme. As Reyner Banham has shown, this "functionalism" was notional rather than real. No laws of function inherent in new building materials prescribed the forms of International Style buildings, nor was it common for any determinate use for a building to prescribe its shape and design. On the contrary, pure, refined and elegant as it is at its best, the International Style is no more than a style, whose historical origins, like those of any other style, are a subject for the historian of ideas.

Without sketching such a history here, the radical difference of this style from the Modernism of Wyndham Lewis can now be briefly stated.[13] First, its forms of abstraction are "idealist" in the sense that they presume to lay bare the spiritual absolute that underlies the surface multiplicity of phenomena. This is true equally of Kandinsky and Mondrian, both of whom wished their art to be a vehicle for the universe to lay bare its ultimate spiritual structure. Lewis rejected such ultimate "truth" as the content of his work, which was to remain on the surface of life, where there was a field of multiplicity and difference. The puritanical geometries of international Modernism derived from de Stijl and Constructivism have a similar basis in Platonic idealism (where the "functional" social utopia originates, it will be remembered). The shift in the philosophy of the Bauhaus from Expressionistic-mystical to technocratic-rationalist is not as revolutionary as it seems, since both the expressionistic abstractions of Kandinsky and the "rational" geometries of Mondrian stem from similar mystical theosophical sources.[14] Similarly, Mies van der Rohe's glass curtain-walls probably originate in Paul Scheebart's expressionistic visions of glass architecture. And it is Mies's mystically pure geometries, refined to an ultimate essence ("Less is more") that finally epitomize the International Style.

As Lewis submitted the presuppositions of his own and others' Modernism to scrutiny during the twenties, he articulated more explicitly and in philosophical form the fundamental preference discernible in his abstractions and in *The Caliph's Design* for surface multiplicity over the "deeper essences" that were the material of Expressionism and its rational offshoots:

> We are surface-creatures, and the "truths" from beneath the surface contradict our values. . . . For us the ultimate thing is the surface, the last-comer, and that is committed to a plurality of being.[15]

The dilemma for Lewis as a painter in 1919, as in 1914, was where, between the refinement of ultimate abstraction and the "unorganised" representation of natural life, his painting should be situated: "The finest Art is not pure Abstraction, nor is it unorganised life."[16] It was a dilemma upon which his painting would flourish; in figurative drawings where our perception of a discernible human figure emerging from the purely "abstract" predilections of the draughtsman for certain lines ("the gaiety that snaps and clacks like a fine gut string") is an almost miraculous astonishment; and in abstractions where form is as detailed and as mysteriously specific in its invention as is Nature itself. These developments in Lewis's art, coupled with his increasing concentration on writing, set him somewhat aside from Modernism, and meant that architecture never became for him a serious practical preoccupation.

Although Lewis scarcely pursued his interest in architecture later in his career,[17] he did give some indication of what his multivalent anti-essentialist architecture might have looked like, first in the painting *Bagdad* (1927),[18] and later in a descriptive passage in part three of *The Human Age, Malign Fiesta* (1955). *Bagdad* appears to be one of Lewis's "Creation Myths," organised

vertically and leading from disorganised elements at the
base up to a variety of natural and geometrical forms,
suggesting that the activity of the imagination and the
spirit (embodied in a dreaming head and an Egyptian
bird) leads to a multiplication rather than a reduction
of forms, creating an environment where the inhabitant
"sees everywhere fraternal moulds for his spirit, and in-
terstices of a human world."[19] In *Malign Fiesta*, Lewis
invents for the Fallen Angels who people his afterworld
a suburb of Hell where the houses are such as his Caliph
might have designed. It is as if, at the close of a career
marked by the frequently disastrous intervention of
politics, Lewis is commenting on the moral ambiguities
of Modernism, by saying that not even a Caliph has
enough power to implement his vision. Only in league
with a power semi-divine can the artist's designs be
made real, but that (God not being interested in power)
the power the artist allies himself to is likely to be that
of the devil:

> The houses were fairly uniform in size but all were in
> ultra-modern design of very different shapes; the
> predominating colour was a dazzling white, but the
> roofs, the doors, or the balconies, might be anything at
> all, provided it was gay enough—a light grey approaching
> rose, strips of startling blue or green, or such colour as
> was designed to correspond with the shape. . . . The
> shapes which presented themselves to Pullman's recep-
> tive mind were numberless. Some of these houses were
> like an enormous box with barrels collected on top of
> it. Others were like bodies of aeroplanes stacked on top
> of one another; and there were yet others which were
> like two halves of an egg stood on end and hinged
> together, with thick pipes (two or three) connecting
> them with the ground, and a small whole egg lying be-
> tween them. Some looked like houses standing on their
> heads, and some looked like boats which had collided.[20]

Wyndham Lewis's Modernism does provide an alternative current to that of the Modernism of the history books. It is zestful, pluralistic and open, where (certainly in architecture) the dominant mode has been until recently solemn, uniform and closed. Its importance within Lewis's own work is complicated by Lewis's constant awareness that it remains a Modernism of possibilities unrealised outside his own visionary expression of it in books and pictures: "I paint pictures of a world that will never be seen anywhere but in pictures."[21] But *The Caliph's Design* vividly and permanently encapsulates a moment when it seemed that that world might become real, when it was possible to believe that the artist had the power not only to invent "a mode that will answer to the mass sensibility of our time with one voice," but that even the "ugliness . . . commonness and squalor" of London could, with will and imagination, be transformed into what Lewis later called "a white and shining city, a preposterous Bagdad."[22]

NOTES TO AFTERWORD

1. Edited by Lewis and published in 1914 and 1915.
2. Ezra Pound, "D'Artagnan Twenty Years After" (1937), rpt. in *Selected Prose*, ed. W. Cookson (London: Faber and Faber, 1973) pp. 423–24.
3. *Time and Western Man* (1927) rpt. (Boston: Beacon Press, 1957) p. 24.
4. *Blast* no. 1 (1914) p. 7.
5. Ibid., p. 139.
6. See Reyner Banham, *Theory and Design in the First Machine Age* (London: The Architectural Press, 1960) pp. 273–75.
7. For Lewis's contacts with Walden, see W. K. Rose (ed.), *The Letters of Wyndham Lewis* (London: Methuen, 1963) pp. 127–28; for contacts with Rosenberg, see Victor Cassidy (ed.) "Letters of Wyndham Lewis to Sidney and Violet Schiff," *Enemy News*, no. 21 (Summer 1985), pp. 9–31. Theo Van Doesburg wrote to Lewis on 3 December 1920 asking him to contribute a London Letter to *Het Getij* (a Dutch literary magazine). Two letters from Lewis to Van Doesburg have been found in the *Dienst Verspreide Rijkskollekties* in The Hague by Andrew Wilson, along with Van Doesburg's marked copy of *The Caliph's Design*, which Lewis presumably sent him in 1921.
8. This idea can perhaps be illustrated by means of an analogy: documentary film-makers wishing to make poetry accessible to viewers sometimes display in a literal-minded fashion the images of a poem carefully synchronized with a reading of the poem. There exists, for example, a BBC film of Robert Lowell in which the poet's reading of "For

the Union Dead" is illustrated by shots of his face pressed against glass, shots of cars, bulldozers, Colonel Shaw's monument, Boston street scenes, and so on. The poem thus steps out of its conventional life within language and becomes at best banal, at worst absurd.

9. *Planners (A Happy Day)*, c. 1913: number M. 145 in Walter Michel's *Wyndham Lewis: Paintings and Drawings* (Berkeley: Univ. of California Press, 1971); *New York* (1914; M. 177).

10. "The New Egos," *Blast* no. 1, p. 141.

11. Charles Jencks, *Modern Movements in Architecture*, second edition (Harmondsworth: Penguin Books, 1985) p. 14. Jencks points out the origin of the concept in the ideas of Coleridge and I. A. Richards.

12. "Wyndham Lewis Vortex No. 1," *Blast* no. 2, p. 91.

13. The history can be traced through August K. Wiedmann's *Romantic Roots in Modern Art: Romanticism and Expressionism: A Study in Comparative Aesthetics* (Old Woking: Gresham Books, 1979); Robert Rosenblum's *Modern Painting and the Northern Tradition: Friedrich to Rothko* (London: Thames and Hudson, 1975) and through the works of Reyner Banham and Charles Jencks previously cited.

14. The symbolic moment when technocratic rationalism overturns expressionistic mysticism is Van Doesburg's 1921 visit to the Bauhaus. Reyner Banham has maintained (significantly) that this was actually not much of an upheaval despite the consequences for the development of a realizable international style. An analogy might be drawn with Marx's materialization of Hegel's absolute idealism, which turned it into a powerful instrument for change. Underlying the rationalism of applied technology in the ideology of the International Style there remains the Romantic and Expressionist ideal of the total work of art: the *Gesamtkunstwerk*; Steven A. Mansbach quotes Laszlo Moholy-Nagy's vision of a society in which art and life are merged, so that art would no longer be a separate phenomenon

> alongside and separated from which life flows by, but [it will become] a synthesis of all the vital impulses, spontaneously forming itself into the all-embracing *Gesamtwerk*

(life) which abolishes all isolation . . .
— *Visions of Totality: Laszlo Moholy-Nagy, Theo Van Doesburg, and El Lissitzky* (Ann Arbor: UMI Research Press, 1980) p. 19.

Such a fusion of individual into group, art into life, was anathema to Wyndham Lewis, and was attacked by him in his 1926 essay "The Dithyrambic Spectator," rpt. in *The Diabolic Principle and The Dithyrambic Spectator* (London: Chatto and Windus, 1931).

15. *Time and Western Man* p. 387.

16. *Blast* no. 1, p. 74.

17. But Walter Michel and C. J. Fox print in their *Wyndham Lewis on Art* (London: Thames and Hudson, 1969) two contributions by Lewis to *The Architectural Review* which show Lewis's continuing interest in architecture. They are "The Kasbahs of the Atlas" (January 1933) and "Plain Home-Builder: Where Is Your Vorticist?" (November 1934).

18. *Bagdad* (M. P38)

19. *Blast* no. 1, p. 14.

20. *The Human Age: Book Two: Monstre Gai; Book Three: Malign Fiesta* (London: Methuen, 1955) pp. 435–36.

21. *Rotting Hill* (1951) rpt. (Santa Barbara: Black Sparrow Press, 1986) p. 238.

22. *Rude Assignment* (1950) rpt. (Santa Barbara: Black Sparrow Press, 1984) p. 208. See also Chapter XXIX, "A Perfectionist," which is devoted to *The Caliph's Design*.

NOTE ON THE ILLUSTRATIONS

THE ILLUSTRATIONS HAVE BEEN CHOSEN by the editor in order to show the range of Wyndham Lewis's work as a painter, both in his period of geometric abstraction (about 1913–15) and in the early post-war period of stylistic change. The medium of each illustration is given, and the dimensions are given in inches with height before width. "Michel" refers to the descriptive catalogue in Walter Michel's *Wyndham Lewis: Paintings and Drawings* (Berkeley: Univ. of California Press, 1971).

Bagdad, 1927 [Michel P38]
Oil on plywood, 72 x 31 *Cover*

New York, 1914 [Michel 177]
Pen and ink, watercolour, 12¼ x 10¼ *Frontispiece*

Timon of Athens, 1913 [Michel 154]
Pencil and ink, 13½ x 10½ *Page* 13

Dancing Figures, 1914 [Not in Michel]
Pencil, ink, crayon, gouache and oil, 8¼ x 19¾ 24

Composition III, 1914–15 [Michel 180]
Pencil and watercolour, 11⅜ x 10¼ 29

Composition VIII, 1914–15 [Michel 184]
Pencil, 12¼ x 9⅞ 32

Abstract Composition, 1914 [Michel 158]
Pen and ink, pencil, wash, 9¼ x 7¼ 38

Composition V, 1914–15, [Michel 186]
Pencil, 12⅛ x 9⅞ 44

Abstract Composition, 1915 [Michel 176]
Pencil, pen and ink, crayon, 12¼ x 10¼ 47

Design for Red Duet, 1915 [Michel 204]
Pencil, ink, watercolour and gouache, 12½ x 9¾ 59

Abstract Design, 1924 [Michel 600]
Pen and ink, wash, 9½ x 7 67

Three Figures (Ballet Scene), 1919–20 [Michel 382]
Black chalk and wash, 15 x 20 70

Composition IX, 1914–15 [Michel 185]
Pencil, 11 x 10¼ 75

Female Nude, 1919 [Not in Michel]
Pencil and watercolour, 11⅛ x 15 80

Figures, 1921 [Michel 457]
Pen and ink, watercolour, 19¾ x 14 86

Siege Battery Pulling In, 1918 [Michel 310]
Charcoal, pen and ink, watercolour, gouache,
wash, 12½ x 18⅝ 92

Figure Composition, 1921 [Michel 456]
Pen and ink, watercolour, pencil, 13⅝ x 17½ 95

Seated Nude, 1919–20 [Not in Michel]
Crayon and watercolour, 18⅛ x 12⅞ 102

Lovers with Another Figure, 1920 [Michel 403]
Chalk, pen and ink, watercolour, wash, 11 x 18 106

Figure Composition, 1912 [Michel 62]
 Watercolour, 12 x 8¼ 114

Seated Nude, 1919–20 [Michel 378]
 Chalk, pen and ink, wash, 10 x 14 129

Tyro Madonna, 1921 [Michel 493]
 Pen and ink, pencil, watercolour, 14½ x 18½ 138

Woman with Red Tam O'Shanter, 1921 [Michel 499]
 Pencil, pen and ink, watercolour, 15⅛ x 18¾ 140

EXPLANATORY NOTES

page line
9 5 : The revised version of *The Caliph's Design* pub-
 lished in 1939 in *Wyndham Lewis the Artist* (cited
 hereafter as *WLtA*) substitutes, as the conclusion
 of this sentence, ". . . modern painting which
 stands to our revolutionary epoch as a legitimate
 offspring of great promise, but which through cer-
 tain weaknesses falls short of what such a relation-
 ship demands."

10 10 : *WLtA* substitutes: "expressionist."

11 27 : *WLtA*: "It is a not quite irrational world!"

12 24 : *WLtA* replaces Survage with Klee. Leopold Survage
and 32 : (1879–1968) exhibited with the Cubists at the 1911
 Salon des Indépendants.

21 2 : *WLtA* continues: "There is no one found to deny
 the hideous foolishness of our buildings, our
 statues, our interiors. The prevalent imbecility of
 Demos is commonplace. But . . ."

21 14 : Characters in Congreve's *Love for Love*, Dickens's
 Nicholas Nickleby, Boswell's *Life of Johnson* and
 Shakespeare's *Henry the Fourth* and *The Merry
 Wives of Windsor*.

22 5 : *Bouvard et Pécuchet* is an unfinished novel by
 Gustave Flaubert, published posthumously in
 1881.

169

22 31 : *WLtA*: "But Butler's, or Chesterton's, or Shaw's . . ."

25 11 : *WLtA* substitutes, probably unintentionally, "destroying."

27 6 : Burlington House is the headquarters of the Royal Academy.

28 15 : Regent Street was originally an elegant thoroughfare, created by John Nash in the early 1800s. Total rebuilding began in 1900, and, according to Nikolaus Pevsner's *The Buildings of England: London (I)*, "has left us with a large number of indifferent commercial buildings."

28 29 : Cecil Rhodes (1853–1902) was the foremost champion of the British imperial ideal in Southern Africa. He left much of his vast fortune to Oxford University, endowing the Rhodes Scholarships.

31 6 : The Albert Memorial commemorates the Consort of Queen Victoria; *Blast* 2 blesses the scaffolding around the monument.

31 16 : *WLtA* corrects and amplifies the first edition's "works" to "modern world."

35 20 : *WLtA* continues: "Look at Van Gogh—though France, where he worked, was very different to industrial England. So in considering . . ."

35 28 : *WLtA* adds: "Subject-matter you have to dismiss as unimportant."

39 30 : *WLtA* substitutes "*faures [fauves]* or wild beasts."

39 34 : This exhibition was held at Heal's Mansard Gallery in August 1919. Lewis wrote of it to his patron, John Quinn: "It has been got up by the Sitwells, and brought over by a dealer called Zborovsky. It contains three excellent Modiglianis (too much Cézanne but very able); a very nice, but slight, Matisse; a lot of stormy, Constable-like Vlamincks;

a few interesting things by Kisling, Survage (do you know him?—a very sweetly-coloured, fantastic brand of cubism, but quite beautiful), and Archipenko. Except for the Vlamincks and Modiglianis, and these Survages, the show is not an important one. Only one small, early, Picasso." (W. K. Rose, ed., *The Letters of Wyndham Lewis* [London: Methuen, 1963], p. 112)

41 24 : *WLtA* adds: "I write for the factory-hand, if by good luck this book should manage to reach him, as much as for the Cambridge aesthete or the Fashionplates of Mayfair. The 'educated' are of course generally unteachable. Heaven forbid that I should aspire to educate the 'educated'!"

43 17 : In a 1921 letter, Lewis describes Alexander Archipenko (1887–1964) as a "well-known Paris-Russian sculptor getting worse every day." (*Letters*, p. 128.)

45 7 : *Architecture: An Introduction to the History and Theory of the Art of Building* (London: Williams and Norgate, n.d. [1912]); Lethaby (1857–1931) was one of the creators of English "Free" architecture. On page 245, Lethaby declares that "except for a hundred or two buildings, London needs to be rebuilt from end to end."

45 38 : *Architecture*, pp. 248–51; Lewis's paragraphing of the quotation indicates his editorial excisions from Lethaby's text.

46 7 : C. H. Caffin (1854–1918) was an American writer on art. His *How To Study Architecture* was published in New York by Dodd, Mead and Co. in 1917.

46 18 : The Woolworth Building (1911–13), designed by Cass Gilbert, was at this time the tallest in the world.

46 27 : The Schiller Building (1891–92: Sullivan and Adler) is adorned with a Renaissance-inspired cupola.

48 32 : Remy de Gourmont (1858–1915), a French writer, was one of the founders of the *Mercure de France*, and was associated with the symbolist movement. The source of the passage is unidentified. Translation:

> Here is the key to explaining why there was a sense of architecture during the Middle Ages: they had no knowledge of nature. Unable to enjoy the earth for its own sake—the rivers, the mountains, the sea, the trees—to stimulate their sensibilities they were compelled to make an artificial world for themselves: to erect forests of stone.
>
> Nature opened itself to man because France and central Europe became criss-crossed with roads, because the countryside became secure and easy of access.

51 13 : *The Young Visiters* was first published in 1919, became a bestseller, and has frequently been republished since. Daisy Ashford was nine when she wrote the book. Pamela Bianco was twelve in 1919, when her drawings were exhibited at the Leicester Galleries in London. Her drawings were published in *Flora* (London: Heinemann, 1919) with verses by Walter de la Mare. As Lewis indicates (page 53), her pictures have a sophisticated faux-naif charm. The Omega Workshops were a company initiated by Roger Fry in 1913. Fry's intention was to provide financial support for young artists by marketing their works and furniture, pottery, etc., made to their designs. After a major public quarrel, Wyndham Lewis left the scheme in October 1913.

51 18 : Lewis attended the Slade School of Art in London from 1898 until his expulsion in 1901.

51 25 : Horatio Bottomley (1860–1933) was a sensa-
 tionalist journalist, politician and swindler.

52 1 : George Formby was an entertainer who sang slight-
 ly risqué songs to the accompaniment of his own
 ukelele.

53 35 : *WLtA* substitutes "sensibility." Lewis's use here of
 the Freudian word "libido" antedates its use in the
 1922 "Bestre" of *The Tyro* no. 2.

57 1 : *WLtA* has " 'dynamic' *idée fixe.* "

58 3 : Lewis refers to Korin's wave screen (*Waves around
 Matsushima*) in the Fenollosa-Weld collection in
 Boston. This screen is a major source of the forms
 and organisation of Lewis's 1919 canvas *A Battery
 Shelled.*

58 4 : Giacomo Balla (1871–1958) painted *Linee an-
 damentali e successioni dinamichi* (*Paths of Move-
 ment and Dynamic Sequences*) in 1913.

58 22 : Koyetzu, along with Korin and Rotatzu [Sotatsu]
 is "blessed" in *Blast* 2. Lewis would have read about
 these artists in Ernest Fenollosa's *Epochs of
 Chinese and Japanese Art* (1912). As a student
 Lewis often drew in the British Museum and
 became familiar with much of the collection: "Even
 when at the Slade School I was directed to go to
 the Print Room at the Museum and study the draw-
 ings of Raphael and Michaelangelo I had always to
 pass between cases full of savage symbols on my
 way to the shrines of the cinquecento." (*Letters*, p.
 407; to James Thrall Soby, 1947.) At the Slade
 Lewis modelled his draughtsmanship (in keeping
 with the Renaissance predilections of the Professor
 of drawing, Henry Tonks) on that of Luca Signorelli
 (ca. 1441–1523).

58 32 : Sung period: 960–1279.

60 5 : Reliefs showing lions and hunting scenes from the palace of Ashurbanipal are in the British Museum. Ashurbanipal (668–626 B.C.) was the king of Assyria.

66 1 : "It is only as an aesthetic phenomenon that existence and the world are eternally justified . . ." Friedrich Nietzsche (1844–1900), *The Birth of Tragedy* (1872), Section 5.

66 18 : J. H. Fabre (1823–1915) was a French entomologist whose work regularly appeared in the pre-World War I issues of *The English Review*. His studies and experiments with insect behaviour showed that seemingly free and intelligent action could be better understood as the product of blind instinct. Reading Fabre enabled Lewis to clarify his ideas about aesthetics and human behaviour, as can be seen from Lewis's 1917 essay "Inferior Religions" (reprinted in *The Complete Wild Body*, ed. B. Lafourcade [Black Sparrow, 1982]).

68 2 : Ma Yüan was a Chinese painter of the Sung period, living in the twelfth and thirteenth centuries. Fenollosa reproduces his *Villa with Pine Tree* (*Epochs of Chinese and Japanese Art*, Vol. 2, between p. 42 and 43) and devotes a paragraph (p. 41) to an analysis of the qualities of the depiction of the tree.

68 20 : Stevenson (1854–94), a Scot, travelled in the hope of mending his health; he died in Samoa. George Borrow (1803–81) was a writer and linguist who also travelled extensively.

69 25 : *WLtA* substitutes: "He was in as limited a way a savage as an American negro. Such people are savages who go in for art . . ." Despite "blasting" Otto Weininger in *Blast* 1, Lewis here accepts his racial stereotyping of Jews. Lewis's racial views are

too complicated to discuss here, but two points can be made: first, that his remarks on Jews and Black Americans here appear to be conditioned by the fact that these people, like Gauguin, are not (like the Hereros and Hawaiians) in their "natural" environment (Israel, Africa); and, second, that this does not make the remarks any less offensive.

69 30 : *Prince Igor* (1890) is by Alexander Borodin, the Russian composer and chemist.

73 5 : "A violet by a mossy stone / Half hidden from the eye!"—William Wordsworth, "She Dwelt among the Untrodden Ways."

74 4 : F. T. Marinetti (1876–1944) wrote the Manifesto of Futurism in 1909: "We say that the world's magnificence has been enriched by a new beauty; the beauty of speed. A racing car whose hood is adorned with great pipes, like serpents of explosive breath—a roaring car that seems to ride on grapeshot—is more beautiful than the *Victory of Samothrace.*"

76 12 : Lipton: tea merchants; Maximilian Harden (1861–1927): journalist, founder of *Die Zukunft* (*The Future*); Madame Tussaud: maker of wax portrait-heads, whose work formed the basis of Madame Tussaud's waxworks in Baker St., London.

76 19 : Euthymol: toothpaste; Tube: the underground railway in London.

76 22 : The remainder of this paragraph does not appear in *WLtA*.

76 28 : Mae Marsh and George Robey were music hall entertainers.

78 18 : *WLtA*: ". . . the cheese, the coal scuttle, or the place of Provençal apples."—alluding to the subject matter (apples) of many of Cézanne's still-lifes and the cubist still-lifes that derive from them.

79 21 : *WLtA*: "Van Gogh, Praxiteles, Giotto,"

85 17 : *WLtA*: "To admire Racine or Corneille, similarly,
 is an amusing affection [*sic*] in an Englishman, but
 those dramatists are trivial beside the Greeks."

85 25 : *WLtA*: "Delacroix and Géricault are great romantics,
 but Burne-Jones, Böcklin and Turner have them
 beat: or in the literary field, Victor Hugo has to hand
 it to Hoffmann, Dostoievsky, or Scott." The re-
 mainder of the paragraph is omitted from *WLtA*.

89 3 : Compare André Lhote, "Cubism and the Modern
 Artistic Sensibility," *The Athenaeum*, September
 19, 1919, p. 920: "[Cézanne] embodies, through the
 Romanticism with which he was impregnated, the
 avenging voice of Greece and Raphael."

89 3 : *WLtA*: "Dahomey."

90 20 : The Russian Ballet performed *La Boutique fan-
 tasque* with Derain's sets and costumes at the
 Alhambra Theatre in London on 5 June 1919. The
 choreography was by Leonid Massin to music of
 Rossini, arranged by Respighi.

93 13 : *WLtA* adds: "It is for the public to take 'movements'
 seriously—not for the artist."

96 13 : *WLtA* adds to this sentence "with one voice, not
 with a hundred voices."

97 5 : For this paragraph, *WLtA* substitutes: "Picasso and
 the men associated with him appear to have taken
 their liberty at once too seriously and not serious-
 ly enough. Picasso has turned painting into an af-
 fair of *modes*—we should not turn the blind eye
 to that fact. He has impregnated the art of paint-
 ing with the spirit of the Rue de la Paix. He really
 has settled down to turn out a new brood of *latest
 models* every few months, which are imposed
 upon the world by the dealers and their journalistic
 satellites, just as a dress-fashion is. This, obviously,

for painting at large, is a bad thing. Picasso's output is something like brilliant journalism of the brush. But a highbrow fashion-expert, *obliged* to seek for an obvious novelty every season, or half-season, is an unsatisfactory sun for a system to have. A less inconstant source of energy would be preferable. — But, of course, all this is in all likelihood not Picasso's *fault*." By 1939 Lewis's opinion of Matisse had considerably altered for the worse, which accounts for his omission from the revised version of this paragraph.

100 10 : André Lhote (1885–1962) exhibited with the cubist painters in 1911, but returned to a traditional classicizing approach in his later work. In an article in *The Athenaeum* describing his first visit to the Louvre after its reopening following the First World War, Lhote singles out David's *Rape of the Sabine Women* for special praise, and goes so far as to say "We consider David as the prototype of the modern painter, as the maker of that revolution which continues in us much more than we continue it." (22 August, 1919, p. 788.) For Lhote's description of Picasso, see page 112 and the note thereto.

100 28 : *WLtA* adds an extra paragraph: "Cézanne remains the father and prime source of all contemporary inspiration in the art of painting. And it is the oddest of ironies that such a one-track intelligence as Cézanne should be responsible for such a chaotic fusillade of styles and stunts: that this great monogamist — this man of *one Muse* if ever there was one — should have ushered in a period of unexampled pictorial promiscuity, and universal philandering."

101 15 : Saskia was Rembrandt's wife and model.

104 15 : *WLtA* omits this sentence.

105 15 : *WLtA* omits this and the preceding sentence.

105 18 : Lewis is mistaken: Matisse was French.

105 24 : Kandinsky's complete abandonment of representa-
tion is variously dated to 1910 or 1913, or is held
not to have taken place at all. Wyndham Lewis was
himself a pioneer of "abstraction" in art.

108 27 : *WLtA* substitutes and adds: "And I cannot avoid
some investigation of the record, both technical
and emotional, of Picasso. For Picasso is the
recognized pictorial dictator of Paris. So the
character and intellect of that one individual
signifies a very great deal to all artists at the pres-
ent time."

109 7 : *WLtA* continues: "For he is such a fine artist that
criticism, except between painters, should be
avoided. But this pamphlet *is* between painters
more or less.
 "It is out of scholarship that this revolutionary
intelligence came armed to the teeth with the
heaviest academic artillery. Picasso was equipped
for the great battle of wits that goes on in Paris
with a thousand technical gadgets, of the most
respected antiquity, which he often has put to the
strangest uses. The exact analogue to this is the
art of Ragtime or Jazz. Picasso stands now against
the Parthenon in the same relation that a great jazz
composer stands to Beethoven. Even Cézanne
Picasso stands on his head. He takes Cézanne at
his word: when Cézanne says (as he did) 'tout est
sphérique et cylindrique,' Picasso parodies this
paradox.
 "With remarkable power . . ."

110 5 : A painting of 1903 also known as *Tragedy*, now in
the National Gallery of Art, Washington (Chester
Dale Collection).

111 7 : Lewis had enjoyed Chaplin films from 1913 or
1914, but he retained a distaste for the pathos of
smallness, as can be seen from his chapter on
Chaplin in *Time and Western Man* (1927).

111 14 : *WLtA* omits this sentence.

111 32 : Pachmann and Moisevitch were virtuoso pianists.

112 13 : "Cubism and the Modern Artistic Sensibility," *The Athenaeum*, 19 September 1919, p. 920; Lewis has substituted "Cézanne" for "He" and from the first sentence of paragraph two of the quotation, he omits the opening words: "With remarkable intuition the young. . . ." In the same sentence "stiff phrases." should be "stiff, substantial phrases—".

112 27 : *WLtA* continues: "An inconstancy in the scholarly vein, might be matched by an inconstancy in the revolutionary. These are . . ."

113 13 : Lhote's article discusses the *Portrait of Clovis Sagot* (1909), which had been exhibited in Paris during the summer of 1919 at the gallery of Léonce Rosenberg (and had previously been shown at Roger Fry's 1910–11 exhibition "Manet and the Post-Impressionists" at the Grafton Gallery in London). Lhote sees the picture as a decipherment of the "riddle" of Cézanne. Picasso's portrait of Gertrude Stein dates from 1906.

113 31 : Possibly the 1910 *Girl with Mandolin* from the collection of Nelson Rockefeller.

115 1 : Probably the phase known as "Analytic Cubism"; Lhote uses the term (while disowning it as figurative) to refer to the sense of space created by the activity of the spectator's eye as it explores planes and returns to the picture's surface.

115 3 : 1911 onwards; the beginning of "Synthetic Cubism" with the introduction of illusionistic woodgraining and lettering, leading to *collage*.

115 30 : *WLtA* omits this sentence.

123 22 : Clive Bell was an influential Bloomsbury critic, married to Vanessa Bell and closely associated with Roger Fry. His book, *Art,* was published in 1914, and popularized the theory (which Lewis opposed as an oversimplification) that the representational elements in painting are irrelevant, formal features alone having significance: ". . . to appreciate a work of art we need bring with us nothing from life, no knowledge of its ideas and affairs, no familiarity with its emotions." (*Art* rpt. [London: Arrow Books, 1961] p. 36.) Lewis's "receptive" artist, enraptured by the contents of his room, is based on Bell's description of the artist in a moment of inspiration: "Occasionally when an artist — a real artist — looks at objects (the contents of a room, for instance) he perceives them as pure forms in certain relations to each other, and feels emotion for them as such." (*Art,* p. 58.)

124 29 : The Omega Workshop did not close down entirely until 1920.

128 8 : French: rapturous swooning.

128 29 : Clive Bell, "Criticism," *The Athenaeum,* 26 September 1919, p. 953.

131 26 : "The Artist's Vision," *The Athenaeum,* 11 July 1919, p. 595. The "refreshment room at South Kensington" is in the Victoria and Albert Museum.

134 21 : *The Weekly Dispatch* was a Sunday newspaper. Picasso, who was in London for a production by the Russian Ballet (with Picasso's costume and set-designs) of *The Three-Cornered Hat,* also expressed himself as "charmed by the naivety" of children's defacements of his poster for the ballet.

139 22 : In place of the following two sentences, *WLtA* continues: "And if Picasso, with all his native Catalan

freshness and *sans-gêne*, succumbs to the classical influences of the French capital, he should be momentarily disowned."

141 8 : Lewis's coinage, from the French adjective *saillant*. *WLtA* prints the conventional English form "salience."

142 19 : *WLtA* continues: "His subject-matter has tended to be constant. His manner he could change no more easily than his *name*."

142 24 : *WLtA* omits this sentence.

TABLE OF VARIANTS

THE DIFFERENCES BETWEEN the present text and that of first publication are listed below.

"Dérain" has been corrected to "Derain" throughout.
"Dégas" has been corrected to "Degas" throughout.
"Bianca" has been corrected to "Bianco" throughout.
Long quoted passages on pages 45, 46, 48–49, 112, 131 and 134 have been indented and set in smaller type and the original quotation marks have been dropped. On page 46, line 12, Lewis's "Etc." has been placed in square brackets.

In addition the following corrections have been made.

Page	Line	First edition text	Present text
21	10	Péchuchets	Pécuchets
31	16	works	world (see Explanatory Note)
43	10	Gaudier Brzeska	Gaudier-Brzeska
45	31	Experience	Experiment (in accordance with the text being quoted)
46	8, 11, 15 & 28	Buildings	Building
46	25	skyscrapers	sky-scrapers
68	30	Hawaian	Hawaiian
79	22	the VII. dynasty	the VII dynasty
79	25	George V.,	George V,
85	24	Hoffman	Hoffmann
111	36	26 September	19 September
119	4	specialized	specialised
124	22	Burne Jones	Burne-Jones
128	16	ecstacy	ecstasy
128	18	ecstacies	ecstasies
142	15	overriden	overridden

183

Printed May 1986 in Santa Barbara & Ann Arbor
for Black Sparrow Press by Graham Mackintosh
& Edwards Brothers Inc. Design by Barbara Martin.
This edition is published in paper wrappers; there
are 400 cloth trade copies; & 176 numbered deluxe
copies have been handbound in boards by Earle Gray.

WYNDHAM LEWIS (1882–1957) was a novelist, painter, essayist, poet, critic, polemicist and one of the truly dynamic forces in literature and art in the twentieth century. He was the founder of Vorticism, the only original movement in twentieth century English painting. The author of *Tarr* (1918), *The Lion and the Fox* (1927), *Time and Western Man* (1927), *The Apes of God* (1930), *The Revenge for Love* (1937), and *Self Condemned* (1954), Lewis was ranked highly by his important contemporaries: "the most fascinating personality of our time . . . the most distinguished living novelist" (T. S. Eliot), "the only English writer who can be compared to Dostoievsky" (Ezra Pound).

PAUL EDWARDS was born in Colchester, England, in 1950. He attended Cambridge University, and later studied the work of Wyndham Lewis at the universities of Birmingham and London. He is the editor of *Enemy News*, the journal of the Wyndham Lewis Society. Mr. Edwards lives in Cambridge, England.